California
APRICOTS

California
APRICOTS

THE LOST ORCHARDS OF SILICON VALLEY

ROBIN CHAPMAN

AMERICAN PALATE

Published by American Palate
A Division of The History Press
Charleston, SC 29403
www.historypress.net

Back cover: Shed boys at the Berryessa Fruit Cooperative. *Courtesy of History San Jose.*

First published 2013
Second printing 2013
Third printing 2013

ISBN 978.1.5402.0765.4

Library of Congress CIP data applied for

For
Marlene Maselli Schuessler,
an inspiring Santa Clara Valley teacher

Contents

INTRODUCTION

A House in the Orchard

I loved looking at the ripe apricots on the trees and trying to pick out just the right one that would be perfect for eating. I imagined how each one would taste. It was like a treasure hunt.
—*Gene Chalupa Venell*

In my memory, the warm summer days in the Santa Clara Valley have an apricot hue. The hillsides around the valley in summer are a soft shade of adobe, brightened by the apricot color of the California poppies scattered within a sea of Spanish oats. The sun in the summer afternoons is a shade of apricot too, and when the apricots ripen on the trees, they join this symphony of color.

On our street in Los Altos, the apricots were ready for harvest near the Fourth of July. They were ripe for less than three weeks. They were free for the taking on hundreds of trees. They were beautiful to look at and tasted even better than candy. What child would not be enchanted?

For those few weeks, we ate our fill and never got sick of them. Our mothers canned them, baked pies and made apricot jam. We helped our fathers cut them, place them on trays, smoke them with sulfur and set them out in the sun to dry.

My sister and I grew up in a neighborhood that bloomed in the middle of an apricot orchard in a valley that, when we were small, was still filled with hundreds of thousands of acres of fruit orchards. Of all the plentiful produce around us, the apricot was, to us, the most memorable.

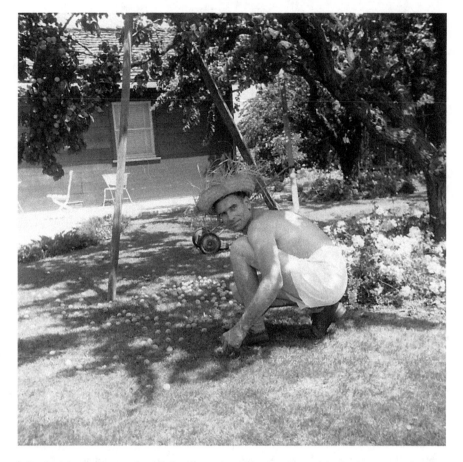

It is a hot day in June, and my father is wearing his swimming trunks (and an eccentric hat we bought in Mexico) as he thins the apricots on our backyard trees. The crop is so big he's had to prop up the overloaded branches. If you don't thin a crop this heavy, the 'cots will be too small and not very sweet. *Chapman family collection.*

Perhaps it seemed that way because the apricot's season was so brief—making the apricot rare, like all great loves. Perhaps we loved them for the warmth they gathered from the sun or for the cool shade of their leaves.

Most likely it was their taste.

Picked warm from a tree, an apricot opens into two bite-sized halves as easily as if it has a dotted line down the middle. The seed at its center infuses the core with a hint of almond: in some parts of the world, the oil of the apricot seed is used instead of almond as a flavoring. The fruit of the apricot carries the scent of citrus and jasmine, peach, gardenia,

honeysuckle and cardamom. When you pop one into your mouth, the taste is rich, sweet and a little bit tart. Filled with antioxidants, beta-carotene, vitamin C, potassium, iron, vitamin A, copper, fiber and lycopene, each apricot contains just sixteen calories.

Not that we were counting.

It was only when we grew up and moved away and tried to find them again that we realized how exotic and how scarce these apricots were everywhere else we lived. How lucky we were to have enjoyed them in such abundance!

Neither of my parents came from an orchard family, and neither was from California. Like most people who love the state, they came from somewhere else.

My father was from Homewood, Alabama, where his father worked in the advertising business and hardly ever removed his tie. My mother was from Spokane, Washington, where her father was a sheriff's deputy. They met when Captain William Ashley Chapman, serving along with millions of other men in World War II, was stationed at Geiger Field, near my mother's hometown.

They knew each other for just six weeks when they married. They were together for six more weeks before my father headed overseas for the last and greatest battle of the war in the Pacific—the Battle of Okinawa.

Reunited, they came to the Santa Clara Valley in 1947 when my father, an engineer, took a job at Ames Aeronautical Research Laboratory at Moffett Field. Ames was a branch of the National Advisory Committee for Aeronautics, a federal agency that later morphed into NASA. It was one of the first places in Santa Clara County to explore the new technologies that would one day transform the area into Silicon Valley. Ames was built on the site of what once had been orchards and bean fields.

At first, my parents lived in Palo Alto, the nearest city of any size to Moffett Field that had housing for them—and there wasn't much housing available even there. Next to nothing had been built for civilians during World War II, so all the returning veterans found housing a challenge.

My parents took what they could find—a rented room in a little house on Palo Alto's Emerson Street that my mother dubbed "Denman's Dump." If that seemed cramped, things got even tighter when my sister arrived that autumn. My mother hoped they could one day buy a house in Palo Alto. My father, it turned out, had other ideas.

All during the last year of the war, in the midst of nightly air raids, kamikaze attacks and anti-aircraft guns booming around him on the little island of Ie Shima, he spent his free time building a house on paper. He sketched

in his pyramidal tent as he worked twelve-hour shifts as commander of C Company, 1902 Engineer Aviation Battalion, United States Army Corps of Engineers. As the war wound down, he wrote my mother:

> *Friday, 15 June, 1945*
> *Ie Shima*
> *We are pretty busy these days but if we ever get any regular time off I intend to play around with our house some more.*

Dad was constructing runways, aid stations, water plants and chow halls under fire. After that experience, he figured it couldn't be so very difficult to build his own house after the war was over:

> *Saturday, 16 June 1945*
> *Ie Shima*
> *You speak of us buying a house. I wouldn't buy someone else's house or one that someone else had built unless it was pretty cheaply priced. I don't believe we'd ever be satisfied unless we planned exactly what we wanted.*

When he got home, he began to plan what he and his family would need. My mother, never much of a risk-taker, wasn't so sure. She may not have liked "Denman's Dump," but she liked Palo Alto. Home to Stanford University, its lovely old homes were large and its neighborhoods neat with sidewalks and mature shade trees. Unfortunately, these same features meant fewer houses to choose from and higher prices.

The prices may have made the difference. In the winter of 1947, my mother gave in, and the Chapmans bought a set of house plans and a lot in an apricot orchard in Los Altos.

Los Altos was then an unincorporated town on the peninsula that stretches along the western edge of San Francisco Bay. It is just a few miles south of Palo Alto and 4.9 miles west of Moffett Field. In the late 1940s, it was transforming itself from a rural village into a pretty town. Almost all of the lots in Los Altos were being subdivided from land that had been in orchard production for at least half a century.

The construction project took two years of weekend work. I heard this story all my life. What a sacrifice my father made for his family, I always thought to myself. It just goes to show you how little I knew him.

When he died in 2010 at the age of ninety—just three months after the death of my mother—I found an old memorandum book in the top

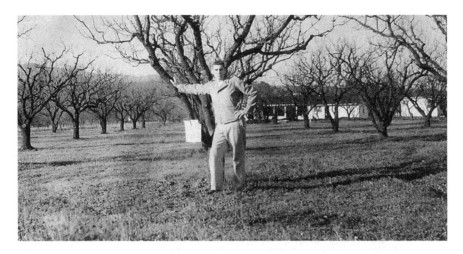

My father poses on the lot in the apricot orchard my parents bought in 1947. It is winter; the branches of the apricot trees are barren and resting. If you could read the sign, it would tell you this is Lot 12, Block 2 of the Doud-Jones Tract. *Chapman family collection.*

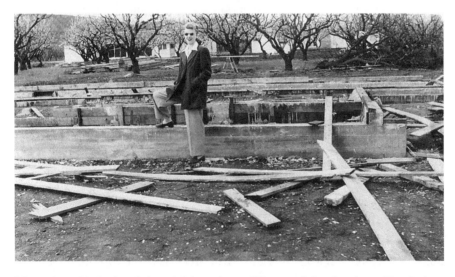

My mother with the foundation of the new house. When my father first showed her the lot, she told him, "I'm not sure I want to be this far out in the country." It is spring now, and the apricot trees are in bloom. You can see a beautiful orchard over her shoulder, beyond our lot in the hills. *Chapman family collection.*

drawer of his dresser. It had rested there for many years with other things he had saved: some old coins that had belonged to his father; notes to himself about how to be a good husband; homemade cards from my sister and me; a Valentine's Day poem from my mother. Among them was this little green notebook.

I opened it and saw a chronological notation of all the hours he had spent building the house, what he had done on each day he worked, and who had helped him. The log showed he spent 369 hours building that house, a figure he wrote at the end of the log in red after totaling up the hours on one of those old-fashioned adding machines with a paper tape. He attached the tape to the page with a paper clip.

I realized then, after he was gone, how much it meant to him, building that house for his family. He had made a safe return from the war—"home alive in '45!" as the soldiers repeated to one another during that last terrible year in the Pacific. He was young and strong. He was in love. He had a family. Now, he was giving his family a home and making it with his own hands. Life was very good.

I was born in the spring, four months after my family moved into the redwood house in the apricot orchard. I posed for one of my first photos in my baptism gown, in my father's arms, in the shade of the apricot tree in the front garden.

As he was building the house, my father preserved many of the fruit trees on the lot and incorporated them into his landscape design. It probably wouldn't happen that way today. But fresh fruit was valuable then, especially to couples like my parents who had seen their families struggle through the Great Depression.

Fruit was, of course, shipped around the nation in 1950 as it is today. But it was not shipped in such large quantities; it was rarely available fresh out of season, and it was, consequently, a lot more expensive.

Add to that the fact that my father had just spent two years in the Atlantic and one in the Pacific on remote islands consuming "K" and "C" rations, and you may get a hint of what those fruit trees meant to my father. Soldiers don't just dream of girls. They also dream of food.

Once back in civilian life, he would not have thought of wasting those apricot trees.

My family was not unique in this. Sparing the apricot trees is what practically everybody did when they built in the Santa Clara Valley then. Almost all of the houses on the lots around us held remnants of the apricot orchards. Some had prunes and cherries and walnut trees too. All of the kids

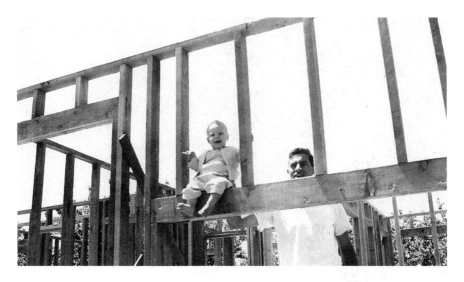

My sister, Kimberly, visits the construction site and is held firmly on her perch by my father. It is summer now. The house frame is almost complete, and it is warm enough for my sister to go barefoot. The apricot trees are covered in their rich, green leaves. *Chapman family collection.*

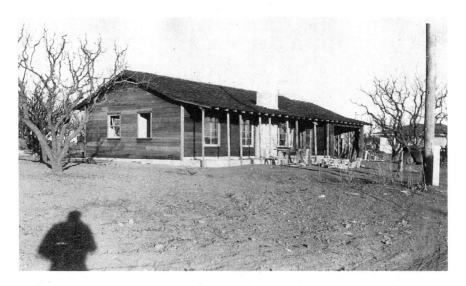

The house is beginning to take shape after a year of weekend work. It is winter again, as you can see from the trees. My father took this photo to send to his parents in Alabama, and I love the fact that he accidentally captured his own shadow, lower left. *Chapman family collection.*

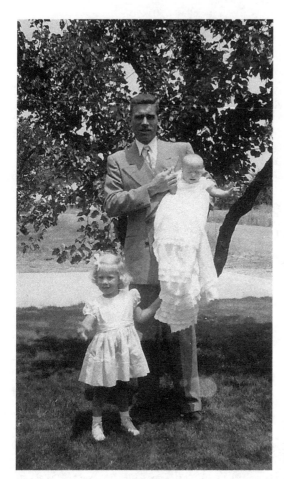

I pose for one of my first photographs, on the day of my christening, in the shade of an apricot tree in our front yard. My father holds me, and my sister hangs on for extra security. My family moved into the house about four months before I was born. If you look carefully, you can see that our street is not yet paved. *Chapman family collection.*

I went to school with feasted on apricots every summer. We couldn't imagine what life must be like for the unlucky people who did not.

My sister and I have tried to remember the number of trees we had on our lot, but so much time has passed that we can only estimate. The house was small, and the lot was about one-quarter of an acre. We think we might have had as many as a dozen apricot trees.

Each mature apricot tree can produce two hundred pounds of fruit in a good season. Multiply that by a dozen, and you can see that my family alone had an annual apricot crop that was about a ton in size.

Locals could sell at least part of their apricot crops to fruit buyers for the canneries and the drying yards. My sister, Kimberly Chapman Moore, remembers during the first few years in our house—when our parents

may have been asking themselves what they were going to do with all that fruit—workers came around before the fruit was ripe and asked each family on the street if they wanted to sell.

As my sister recalls: "It seems to me that they wanted the apricots to be green, with just that faint reddish color they get in one spot as they are just beginning to ripen. I remember that because it seemed so strange that anyone would want apricots that were so green."

It was not a large payday for suburban orchardists if they did sell this way. "Dad was paid a small amount per lug," my sister says. "About fifty cents, I think. And it seems that the truck with the lugs went all over the neighborhood dropping off the wooden boxes first, then returning to pick them up later when they were full."

Some years—and that must have been in the years when apricot prices were high—you could sell your entire tree-ripened crop to a fruit buyer, and he would send around a crew to pick it for you. A number of people we knew did that at least some of the time. The pickers would sweep through the trees like locusts, and the fruit disappeared all at once. My sister and I always thought it must be very sad for the children who lived in these homes.

At our house, the apricots vanished gradually over about three weeks as our parents worked to preserve the fruit. In late July or early August, Dad dug a hole in the garden to bury the last of the rotten and damaged crop. "Apricots," say locals, "Are green yesterday; ripe today; and rotten tomorrow." The days of fresh apricots are always over much too quickly.

Though we did not make our living from the fruit trees, the apricots' seasons put a frame around our year. Apricots are deciduous, and in fall we raked their leaves into big piles. Then—before clean air regulations—my father burned the leaves in an incinerator he built in our backyard. The air was filled with their spicy scent.

You can tell it is winter in our family photographs by the apricot trees' barren branches. Their pinkish-brown wood grows gray in winter, and all the trees look as if they might be dead.

Then, in the spring, two weeks or thereabouts after the almond trees erupt into bloom, the apricots blossom. The Santa Clara Valley was filled with blossoms in the spring. Of the millions of commercial fruit trees that had once dominated the valley's landscape, many trees remained until the last few decades of the twentieth century.

In the summer, when school was out and the weather was warm, my sister and I knew it was time to come in for lunch when we heard the distant noon whistle blow.

The house in the apricot orchard shortly after it was completed and landscaped. In addition to all the apricot trees in the back, Dad left two in the front yard. You can see the branches of one of them, at left. *Chapman family collection.*

"Where does that whistle come from?" I asked my father one day.

"Why, it comes from the cannery," he told me. It certainly was convenient, this cannery, I thought to myself. To have that whistle blow at noon like that, to remind children to go in for lunch.

In Los Altos, even our city hall, library and police station were built in the middle of an apricot orchard. When you stopped by to check out a book, you were reminded of the apricots' seasons and our city's orchard history.

During all the seasons, the apricots brought interesting people into our lives. There was Nick Vojvoda, who came around twice a year and knocked

on our door to see if we wanted him to spray our trees, which we always did. As far as I knew, he sprayed everybody's trees.

There were the Mexican-American families who picked the fruit if you sold your crop to the canneries. There were the farmers who hired local kids to cut their apricots in summer for drying. There was the old, old man who came around one year in the old, old truck and sold us fresh manure from a local farm. My father, with his soft heart, bought the man's entire truckload.

Like so many happy things in life, my family's relationship with the abundant apricots of the Santa Clara Valley had come about by accident. If county businessmen had not lobbied the federal government to build Moffett Field amidst the orchards of Mountain View in the 1930s, there would have been no Ames Research Center in the postwar years at Naval Air Station Moffett. If there had been no Ames, my father might never have come to California.

And what about our choice of towns to live in? Palo Alto, where my mother had hoped to buy, would have been a wonderful place to grow up. But it sits on the northern edge of the Santa Clara Valley and was not, in those days, filled with apricot orchards.

Our family's series of lucky accidents placed us, and the many other families who moved to the valley after World War II, in a position to straddle the region's two economies. Agriculture was both its past and its present when my parents came to California. Technology, which supported our family, was a small part of its present but became all of its future.

In all those years, I never thought to ask anyone why. Why *were* there so many apricot trees all over the place? Why were there so many orchards? Nobody considered this a worthwhile subject for study in our classrooms. I never even got to go on a field trip to see that wonderful cannery with the convenient noon whistle.

But, since my parents lived on that same street in Los Altos for the rest of their long lives, the life of the valley remained part of my own. When they died, I wasn't surprised to find a small, newly planted Blenheim apricot seedling just outside our back gate.

What an optimistic thing it is to plant something—whether one is eighty-eight years old, as my mother was when she planted that apricot tree—or in one's twenties, as my parents were when they planted their house in the orchard. My family's story was set, like a graft, on to an apricot tree. It was surrounded by the much larger tale of a vast orchard that was well worth remembering. I discovered I wasn't the only one to feel this way.

The David and Lucile Packard Foundation funded by a trust from the late founder of Hewlett-Packard and his family, still cultivates a working apricot orchard of more than sixty acres in Los Altos Hills. And in 1997, when the late Steve Jobs of Apple bought the house next door to his in Palo Alto and asked for permission to demolish it, it wasn't because he wanted to build a bigger house. He wanted to fill the lot with apricot trees, like the ones that had surrounded his childhood home in South Los Altos.

Many Californians still love the link the apricot trees make to our agricultural past. If it seems curious that this exotic fruit would come to be cultivated in a wild valley in the West, history is full of such curious tales.

Like my own family's journey to California, it took a number of accidents of history to lead the apricot to its new and fruitful home.

CHAPTER 1

Padres and Apricot Trees

My sister and I still remember the sounds of the orchards, especially in the early morning. The 'cots plunking in the buckets. The rustling of the leaves. The men talking quietly in Spanish. These are the sounds of my childhood.
—Louise Pavlina Hering

Luke Pavlina came to America in 1913 when he was seventeen. The land of his birth, a piece of the Balkans that was sometimes part of Italy and later part of Yugoslavia, was then a piece of the Austro-Hungarian Empire. It was also on the cusp of being torn apart by the Great War.

Pavlina left it all behind to come to California's peaceful Santa Clara Valley. The sun-kissed land had a climate that was like that of his homeland. Here, he did the work he knew: he worked in the orchards.

By 1920, he had saved enough to buy his first five acres of orchard land on El Camino Real, near Mary Avenue, in Sunnyvale. In the next two decades, his operation would grow to thirty-four acres where three generations of Pavlinas would cultivate apricot trees.

The fact that Pavlina's farm fronted on El Camino Real ties his story to early California history. It was along El Camino Real—what became this Royal Highway, in any case—that the Spanish soldiers and padres marched into California to build their settlements.

This tiny invasion by a handful of Spaniards brought unimagined changes to California, yet the story of the Santa Clara Valley's apricot orchards cannot be separated from it. Agriculture, irrigation and fruit

Vintage postcards from the early twentieth century could still find corners of California that looked as they did when the Europeans arrived. This one says on the back: "In spring, the California county-side presents vistas in an unbelievable profusion of floral beauty." *Author's collection.*

from distant lands were among the things these European settlers brought with them.

Until the Spanish came, the California landscape had been especially isolated from exploration by its geography. With unwelcoming deserts to its south, formidable Sierras to its east and the not-very-pacific Pacific Ocean to its west, it was, as Shakespeare wrote about England, " ...a fortress built by Nature for herself."

Early mapmakers thought it could be an island, and it might as well have been, considering its isolation. It took a long, long time for European explorers to surmount the obstacles that served as guardians of its natural wealth and beauty.

In the sixteenth century, at least two Europeans sailed the California coast and made landfall. Though they did not, alas, bring apricot trees with them,

they are important to this story because their explorations led to the many more that followed. There were probably even more adventurers than the ones we know about who sailed the California coast. The oral tradition of the California Indians includes tales like this one, recounted by Edna Kimbro and Julia Costello in their book about early California: "In the old days, before the white people came…there was a boat sailing on the ocean from the south. Because [the people] had never seen a boat, they said, 'Our world must be coming to an end. Couldn't we do something? This big bird floating on the ocean is from somewhere, probably from up high. Let us plan a feast. Let us have a dance.' They followed its course with their eyes to see what it would do."

Juan Rodríguez Cabrillo sailed up from Baja California in June 1542, at the behest of the Viceroy of Mexico—then called New Spain. He is the first European—whom we know of—to walk on California's shores. On September 28, 1542, he and his fleet entered San Diego harbor, disembarked to restock and staked a claim there for Spain.

Heading farther north, Cabrillo was the first European to see an early form of California land management. Arriving near what is now San Pedro Bay, he saw the coastline engulfed in the thick smoke of a chaparral fire. California's coastal Indians often set these fires to clear the underbrush surrounding the oaks, making it easier for them to harvest the acorns, a staple of their diet. Cabrillo dubbed San Pedro *Baya de los Fumos*, or Smokey Bay.

For the next three months he sailed, missing the narrow entrance to San Francisco Bay but stopping in Monterey Bay, which he called *Bahia de los Piños*, literally Bay of the Pines. Point Piños, at the south end of Monterey Bay, is a remnant today of that early name.

The months of late summer and early fall are often the best time of year in Northern California. Cabrillo clearly thought so, writing *"delicioso"* in the ship's log.

But the winter weather was less delicious, and the storms of November 1542 made his return journey difficult. In December, Cabrillo and his ships stopped at one of the Channel Islands. There, near Christmas Eve, Cabrillo slipped on some rocks—some sources say he fell in a skirmish with the Indians—and the captain was injured. Sources disagree on whether he injured an arm or a leg. But the broken bone became infected, and Cabrillo died on January 3, 1543. He was buried—according to legend—on San Miguel Island.

In 1579, thirty years after Cabrillo, Francis Drake sailed around the world and stopped somewhere in Northern California. Queen Elizabeth wanted

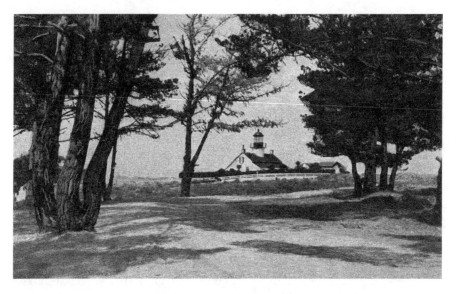

A vintage postcard made in Germany in the early twentieth century shows the Point Piños Lighthouse, Monterey, California. The name of the point comes directly from the explorer Cabrillo, who called the nearby bay *Bahia de los Pinos*, or Inlet of the Pines. *Author's collection.*

Gaspar de Portolà brought a very small group with him when he entered California. Since the camera was still a century away, we have only sketches like this one on a vintage postcard to mark his journey. It takes a few liberties. By this point in the trip, the soldiers' clothes were in tatters and the Native American men wore even less than those pictured here. *Author's collection.*

to keep his journey a secret since she did not want to aggravate the Spanish, her international rivals. Drake received a knighthood for his trouble and came home with a hoard of gold and other treasure pirated from Spanish ships, so his adventure can't have been much of a secret. Still, the records of his expedition were first suppressed and then were lost in a fire.

Historians do know, from the testimony of his crew, that he stopped to resupply at a bay in Northern California. On that stop, he held a peaceful meeting with a group of native people who watched in amazement as he erected a cross and conducted the first Protestant service in California. By tradition, the place he disembarked is an inlet just north of San Francisco, now called Drake's Bay.

But neither of these expeditions brought either settlers or exotic fruit trees. For the next two centuries, while the eastern coast of North America was growing into thirteen productive colonies of England, California remained unexplored by Europeans, in the shade of its redwoods and behind the shroud of its coastal fog.

By the 1760s, the Russians had begun sailing from Alaska into Northern California to extend their search for furs. The King of Spain decided his nation needed to get a better foothold on the California coast.

In 1767, Gaspar de Portolà was ordered by the viceroy of New Spain to take a party of explorers, missionaries and cattle into Alta California. Franciscan father Junípero Serra joined the expedition with the goal of establishing at least two mission settlements—one in San Diego and one in Monterey, where a bay had been spotted by both Cabrillo and the explorer Sebastián Vizcaíno. During this first journey, Portolà and his men missed Monterey but managed to gaze on San Francisco Bay from the Bay Area's surrounding hills.

For the soldiers and the politicians, the missions were a way to create settlements that would extend political power. For the church, the missions were designed to create parishioners. The Franciscans hoped to convert indigenous people and save their souls.

Based on their work in Baja California, the padres expected they could raise the food they needed to survive. If the land was good, they might also be able to grow enough to feed the mission and any converts they might make, as well as teach the skills of ranching, farming and irrigation. If the land was better—as it turned out to be in the Santa Clara Valley—the missions could send home the surplus as tribute to the Spanish king.

What a strange journey it was, this first trek by Europeans along the California coast. The soldiers and padres saw a thriving native culture around them, but one that was very different from their own.

They met Indians who had never seen European clothing—never set eyes on a gun—never heard the whinny of a horse. Villagers greeted them and sent out word about the fabulous men. Crowds gathered wherever the Spanish camped, watching the interlopers. The Indians played music, and, as was their custom, they danced and danced.

Historians Rose Beebe and Robert Senkewicz have pulled together and translated many of the original documents from this period in *Lands of Promise and Despair*. From them we learn the padres began immediately trying to convert the native Californians. At the same time, the Spanish found their natural curiosity invasive and annoying, forgetting, perhaps that they themselves were the strangers.

As Father Juan Crespí wrote, "These dances lasted all afternoon and it was very difficult for us to get rid of these people. They were sent away and with gestures were told emphatically not to come during the night and disturb us. However, it was all in vain. As soon as night fell they returned playing some pipes. The noise grated on our ears."

The Spanish were amazed by California. The land was covered with wildflowers, grassland and oak trees. There were foxes practically underfoot, and they could see grizzly bears feeding in the foothills. Most surprising of all were these curious indigenous people.

Among them were hundreds of native groups. Some traded with one another, and some were mortal enemies. Some spoke similar languages to one another, and some could not understand the language of nearby villages.

From the Ipai and Kiliwa in the southern part of California, to the Miwok, Ohlone and Yokuts in Northern California, there was no central organization among these thousands of people designed to deal with a cultural assault on their entire way of life.

How could there have been? Nothing like this visit from the Spanish had ever happened before. No one, among either the native Californians or the Spanish, could see into the future.

What the future brought was great sorrow for the indigenous people. In the decades during which the Spanish ruled California, its Indians saw much of their world swept away.

Among the people they met were some kind and loving padres who practiced the Christianity they preached and some who did not. They met ethical, humane soldiers like Juan Bautista de Anza and found other soldiers to be wicked and cruel. What no one foresaw was the impact of European diseases on people without immunity to them. Death from disease was the greatest unintended consequence of Spanish settlement in California.

Botanist Mary Elizabeth Parsons wrote in 1902, "California, with her wonderfully varied climate and topography, has a flora correspondingly rich and varied, probably not surpassed by any region of like area in the Northern Hemisphere." *Author's collection.*

Historians, such as Edna Kimbro and Julia Costello, still debate why so few invaders could have caused so much change, a question that occurred to a German traveler they quote who visited one California mission in 1806: "Two or three monks, and four or five soldiers, keep in order a community of a thousand or fifteen hundred [natives], making them lead a wholly different course of life from that to which they had been accustomed."

All this was in the future as Portolà and a handful of Spanish-speaking travelers marched into California.

To these men of the eighteenth century with firm views on king, country and church, the most curious thing about the native men they met was the way they dressed, or actually, the way they didn't dress. Father Serra's first impressions of this surprising aspect of the exploration can be found in a contemporary letter translated by C. De Murville in *The Man Who Founded California*: "I saw something I could not believe when I had read of it, or had been told about it... They were entirely naked, as Adam in the Garden...We spoke a long time with them, and not for one moment, while they saw us clothed, could you notice the least sign of shame in them for their own lack of dress."

It was one of the earliest indications Europeans came across of the mildness of the California climate.

Along with their plans to settle the land and convert the inhabitants, the expedition brought something else, as agricultural expert Edward J. Wickson pointed out more than a century later: "Credit is given to the secular head of the expedition, Don Joseph de Galvez, representing the King of Spain, for ordering the carrying of seeds of fruits, grains, vegetables, and flowers into the new territory, and from the planting at San Diego the same varieties that were taken to the twenty missions afterwards established."

Serra, who traveled with Portolà, was from the island of Majorca, a place with a coastline and climate that look a lot like California. Unlike California, Majorca had been repeatedly conquered over the centuries—by Romans, Vandals, Moors, Muslim caliphates and by the French kingdom of Aragon. By the time Serra was born in Majorca in 1713, it was ruled by Spain.

The Arabs had brought agriculture and irrigation to the island, and now Serra brought these with him to California. It may not be a coincidence that one of Majorca's orchard crops then, as now, was the apricot.

Serra's colleague and friend on the journey, Juan Crespí, was also from Majorca and was instrumental in helping Serra establish the first missions and the first mission gardens. With Portolà, he walked into the Santa Clara Valley and was one of the first explorers to tell us what it looked like.

Recounted by Lorie Garcia, George Giacomini and Geoffrey Goodfellow in their recent history of Santa Clara, Crespí described the valley as "a plain some six leagues long, grown with good oaks and live oaks, and with much other timber in the neighborhood. This plain has two good arroyos with a good flow of water, and at the southern end of the estuary there is a good river, with plenty of water...This entire port is surrounded by many and large villages of barbarous heathens who are very affable, mild, and docile, and very generous."

Walking the path that became El Camino Real, the Portolà expedition—after several tries—found a spot on Monterey Bay for Northern California's first Spanish fort, or presidio. Hundreds of miles from their homes in Mexico, soldiers were stationed at this tiny outpost.

On June 4, 1770, the Franciscans set up an altar under the skies there, hung bells from an oak tree and held their first mass. It was here Father Serra dedicated the first Spanish mission settlement in Northern California.

Whatever else might be said about Serra, he clearly had an eye for real estate. Within a year of coming to Monterey, he had moved that first northern mission to a new location a few miles away on the Carmel River, one of the prettiest spots in California. There this mission planted its first garden of fruit trees and vines.

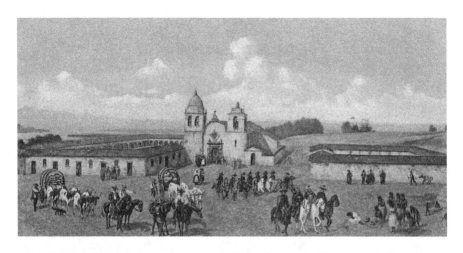

A detailed drawing on a vintage postcard of Mission San Carlos Borroméo de Carmelo, otherwise known as the Carmel Mission. Father Junípero Serra made this mission his headquarters from the time of its construction in 1771 until his death at the mission in 1784. *Author's collection.*

Serra was fifty-six years old when he came to California: quite an old man for the eighteenth century when life expectancy for Spanish men was only slightly more than thirty years. Though he has somehow come down to us through history as a large, jolly fellow, he was, in fact, small and wiry. When his remains were exhumed in 1943, anthropologists estimated his height at five feet, two inches and his weight at about one hundred pounds. All that walking would make most people as slender as he.

His written observations on California are often meant for administrators back in Mexico as Serra biographer De Murville points out. Still, they do give us some insight into his first impressions: "The missions to be founded in these parts," wrote Serra, "will enjoy many advantages over the old ones [in Baja, California], as the land is much better and the water supply is more plentiful. The Indians, especially of the west coast seem to me much more gifted; they are well set up, and the Governor looks upon most of them as likely Grenadier Guards because they are such stoutly built and tall fellows."

Though he did not turn the Indians into Grenadier Guards, he did teach many of them about his religion. From 1769, when he established Mission San Diego, to his death in Carmel in 1784, Serra walked the rough paths up and down the state and supervised the construction of the first nine missions in a chain that would eventually total twenty-one. At least once he returned

to Mexico City—not an easy thing to do when the trip involved both the dangers of sailing and the travails of walking. His round trip took a year.

Cattle—for hides and tallow—helped sustain the missions, as these were the valuable commodities that could best be shipped and traded. Hides were the primary products of the first missions and pueblos. When these hides were dried, they could be easily tossed onto the deck of a ship and became so well known in the East that they were nicknamed "California dollars."

While Serra supervised his fellow monks in the work of ranching and farming, he baptized hundreds of native people and enlisted them to help him tend mission gardens throughout the region. Thus, California's *Indios*—as the Spanish called them—were the state's very first orchardists.

In 1776, Spanish settlement in California expanded when the first civilian settlers came north from Mexico with Captain Juan Bautista de Anza. Serra had encouraged this. He had feuded with presidio commanders about the way the soldiers were treating the Indian converts—most particularly how they were treating the women. He hoped settlers with families would encourage better behavior among the men.

The chaplain on the journey with Anza was another Franciscan, Pedro Font, a well-educated, Spanish-born and somewhat fussy traveler. When we meet him in the journals he wrote as he traveled, he appears a very odd choice for a missionary with his less-than-diplomatic observations.

At the Colorado River, he sees his first Californian Indians and calls them "filthy" and recoils from "their constant passing of wind." At Mission San Gabriel, in present-day Los Angeles, he pronounces the food "vile" and "disgusting," adding, "And it doesn't help that we eat without a table cloth on an old door…so encrusted with grease that one can scrape the filth with a knife."

Why Font chose to minister in the wilderness is certainly one of California history's bigger mysteries—though his pithy commentary does help make his journals much more lively reading than those of his contemporaries. According to Beebe and Senkewicz, as Font camped near present-day Paso Robles, he railed against one California impediment to delightful camping: "The fleas on this site were especially mortifying. We had already encountered them at the missions, but never as hungry, as numerous, or with such a hard bite. They seem to be a real plague in this land, particularly when the weather warms up. Not only in the huts or sheds but in the fields, the trails, or at any stop, they are present!"

Font's consternation with these pests was clearly shared by others. The Spanish later memorialized them in the name of a road that travels between

Santa Clara County and San Mateo County. Today, you can still travel on the Alameda de Las Pulgas—the Avenue of the Fleas.

When Font, who had been so critical of everything and everyone he encountered, began to write glowingly about the California landscape, it is clear he meant what he said. In the translation in *Lands of Promise and Despair*, Font's words have a haunting beauty: "The land is moist and the hills have an abundance of rosemary and herbs, sunflowers in bloom, vines as plentiful as a vineyard…In the plain, an endless herd of deer ran like the wind after having spotted us, a low flying dust cloud moving over the earth. Geese, ducks, cranes, and other birds crowded the river. During the day, we saw several Indians, all unarmed and completely naked."

The way things grew in California was a key to its future. In capturing this landscape as he did and later publishing his journals, Font made others aware of the richness he found.

Meanwhile, he and the Anza party met Serra in Monterey and then traveled north to explore San Francisco Bay. When they camped near what is now called Stevens Creek, Font named it Arroyo San José de Cupertino, a shortened version of which was later used to name the city of Cupertino. Traveling further north, Font pulled out an old instrument he carried called a graphometer to measure the tree that gave its name to Palo Alto.

After walking with the expedition around San Francisco Bay, Font returned with Anza to Carmel, where he had a delightful time—in spite of the food, the fleas and the natives—gossiping with Serra and the other padres. From there, this colorful character headed back to Mexico and out of California history.

But thanks to Font's explorations with Anza, and Serra's persistence, the region just south of San Francisco Bay got its first civilian settlement. On January 12, 1777, the padres dedicated Mission Santa Clara de Asís, the church that gave its name to the county. It was the eighth mission in California and claimed the land from San Francisquito Creek, in present-day Palo Alto, to Llagas Creek at the south end of the valley in what is now Gilroy. Within six months, families from Mexico headed into the Santa Clara Valley and founded the nearby pueblo town of San José.

The settlers and padres had little understanding of how rivers in California come and go from winter to summer, so flooding required them to move Mission Santa Clara a number of times before they finally found a dry spot for it. In spite of the problems, it became clear very quickly that the lands of the Santa Clara Valley were rich for ranching and farming.

In the space of just a few years, the pueblo near the mission was able to harvest two thousand bushels of corn—enough to feed the presidios of both Monterey

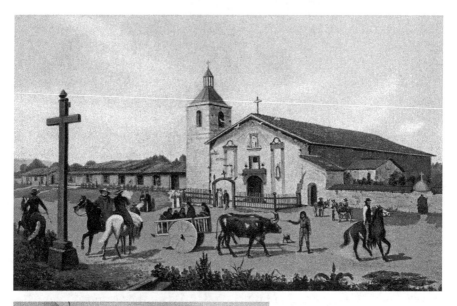

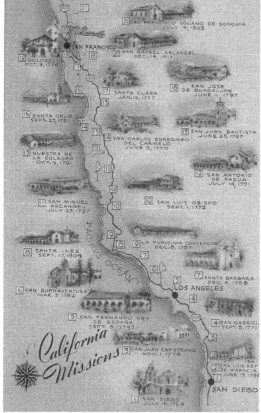

Above: Mission Santa Clara de Asís was established in 1777 and gave its name to the surrounding valley. This drawing on a vintage postcard shows the mission in its earliest days. Though the building has been rebuilt many times, the wooden cross in front of the mission still stands today. *Author's collection.*

Left: A vintage postcard map of the Spanish missions in California. There were eventually twenty-one of them that stretched from San Diego in the south to Sonoma in the north. *Author's collection.*

and San Francisco. More than one source reports that the Franciscans also planted fruit trees that first year. As University of California professor Edward J. Wickson wrote in the early twentieth century: "Scarcely had six years elapsed subsequent to the settlement of the pueblo of San José on its present site, before the inhabitants were enjoying the benefits of luxurious fruits. Before 1805 more was grown than could be disposed of in its natural state."

An analysis done by the University of California–Davis cites the year 1792 as the first year of a significant apricot crop in California, coming from the area "south of San Francisco." The Davis analysis agrees with Wickson's research that apricot seeds or seedlings were brought north in the very early days of the mission settlements and were planted in the gardens of Mission Santa Clara.

That is confirmed in a contemporary report, quoted by Santa Clara Valley writer Yvonne Jacobson, from English naval officer Captain George Vancouver, who charted the coast of the Pacific Northwest and Northern California. In 1792, his expedition visited Mission Santa Clara: "[He] noted a fine small orchard of apple, peach, pear, apricot, and olive trees, as well as vines. All he said, flourished except the grapes but he felt the failure was due to lack of knowledge on the padres' part, not lack of good conditions."

It is one of the first records of an apricot orchard in the Santa Clara Valley.

Just as the El Camino Real connects California from south to north and weaves the story of its past into its present, the fruit orchards of the padres also became woven into the fabric of California.

Carried north by Spanish soldiers and planted by Franciscan missionaries, the apricot tree was nurtured by workers from native groups of Cuhuilla, Patwin, Chumash, Yokuts, Ohlone and more. As Edward Wickson wrote a century later, it was from this curious beginning that the apricot would thrive:

> *The fertility of the soil was supplemented by a peculiarity of climate that enabled trees to grow many more weeks in the year than in other countries, while during the season of rest there was no freezing weather to chill their sap or delay their progress in the spring. The result was that a very few seasons brought orchards to a condition of fruitfulness. All this was demonstrated by the experience of the Fathers at the Missions, but even with this experience before them, the early horticulturists of the valley [would be] astonished by the result of their work.*

In California, at a time of great change and turmoil, the apricot had found its paradise.

CHAPTER 2

Travels with the Apricot

We helped Dad carry the trays to the roof of our house where the apricots lay to dry, exposed to the sky night and day. After a week, the 'cots were ready to eat, shriveled in size, shape and weight, but sweeter than a robin's song.
—Lisa Gutt Arnold

To those who grew up surrounded by neat rows of apricot trees in the Santa Clara Valley, it did seem heavenly. At the end of the eighteenth century, however, the valley was still a wilderness with just a handful of these exotic fruit trees in a few scattered mission gardens and ranchos. A passage from the period novel *Ramona*, by Helen Hunt Jackson, is evocative of those early days of fruit cultivation in California: "And the delicious, languid…summer came hovering over the valley. The apricots turned golden, the peaches flowed, the grapes filled and hardened, like opaque emeralds hung thick under the canopied vines."

Jackson traveled California in the nineteenth century with a commission from the United States Bureau of Indian Affairs. Her firsthand observations, only a few decades after the end of the mission and rancho eras, are a striking feature of *Ramona*, a tale about early California that was one of America's bestselling novels in the nineteenth century and is still in print today.

As the writer noticed in her travels, it was the isolated nature of these early orchards in the broad expanse of Alta California that made them so fascinating to early visitors. In spite of the richness of the climate for agriculture, it was still the production of cattle and wheat that dominated the state for many years.

In the meantime, while the orchard business was so limited, the apricot remained a tasty treasure enjoyed by a lucky few.

To know why it eventually became so successful in the Santa Clara Valley, it is helpful to know more about where the apricot came from. Like all transplants to California, it had a long and rich history before it immigrated to the Golden State. As is the case in the movement of people around the globe, the movement of the apricot involved many years, as well as many thousands of miles.

Like people who migrate, the apricot tree took uncountable routes and arrived at its various destinations in scores of different ways. Its general movement, scientists believe, has been from the East to the West.

Edward J. Wickson was the University of California's most noted agricultural expert in the early twentieth century. In his writing, he points out that something about the way an apricot tree grows led many scientists to believe it was a coastal fruit:

> It is often claimed that situations directly subject to ocean influence are best for the apricot. It is noted by many observers that the apricot "points its best branches to the ocean, in the very teeth of the constant breeze, and the landward limbs and twigs bend up and endeavor to reach the same direction. This is patent in every tree, and in the long orchard rows is very striking." This is taken to signify the special liking of the tree for the vicinity of the coast. It is well enough to interpret it that way, providing one does not lose sight of the perfect success of the apricot in the interior as well.

The apricot *is* very selective in the climates it likes, and it is true that the mildness of some coastal climates is agreeable to the apricot. Like many fruit trees, it needs long, dry, warm summer days for its fruit to ripen. Unlike many, it enjoys a cold winter, yet it won't tolerate frost in the spring when the tree is in bloom. It doesn't like rain or frost later in the spring when the green fruit is beginning to appear. This exacting combination limits the success of the apricot to just a few regions of the world—the Santa Clara Valley being one place it came to like very much.

The valley that turned out to be ideal for this finicky fruit was not its native land. In seeking its origins, science turns to the pomologist for help. A pomologist studies fruit. In the science of pomology, the common apricot is called *prunus armeniaca*. The apricot is classified in the subgenus *prunus*. Other species of *prunus* include peach, cherry, plum and almond. They are often called "stone fruits" and are enjoyed by chefs around the world.

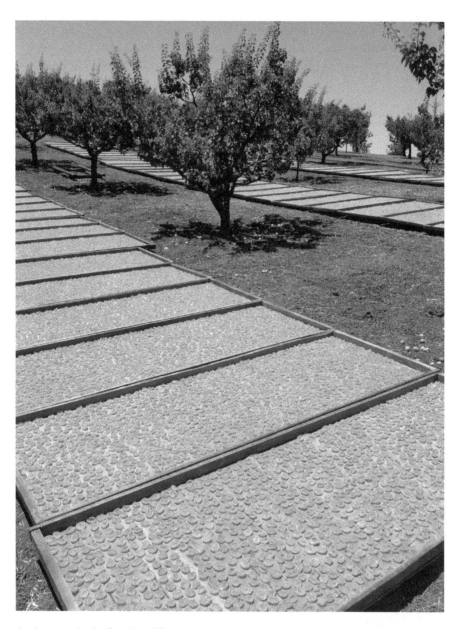

Apricot trees in the Los Altos Hills are surrounded by drying trays on a summer day. If you look carefully, it does appear that the trees are leaning—just a little bit—toward the ocean, which would be to the left side of the photo. *Photo by Robin Chapman.*

The premier pomological expert on the subject of the apricot is Jules Janick of Purdue University, who writes lovingly about these fruits he has spent his life researching. "Their exquisite flavors and gorgeous appearance have made them much admired through the centuries and they have been lauded in poetry, song, and art. In addition stone fruits represent important and valuable fruit crops through the temperate and subtropical world, for fresh and processed products."

All of the *prunus* fruits have been very successful in California. Of these, the apricot is placed botanically between the plum and the peach. In the Middle Ages, it was believed to be a sort of early peach.

The English name for the fruit may be derived from the Latin words *arbor*—meaning "tree"—and *precox*—from the word *praecocia*, meaning "early" (as in precocious). Thus, the apricot was a tree with an early fruit—when compared with its botanical cousins, the plum and the peach. In 1551, William Turner, referring to the "abrecock or "hasty peche tre" wrote, "The hasty peche tre hatch much broader leves then the peche tre and hys fruite is a great tyme sonner rype then the peche is."

If the first piece of Latin in the apricot's botanical name, *prunus*, identifies it with the prune, the second word, *armeniaca*, identifies it as coming "out of Armenia," thus, in its botanical name, the apricot—the early tree—is also the Armenian prune. It is called this because early scientists of the West, like Turner, believed it came to them from the land of Armenia.

In modern times, archaeologists have found apricot pits in Armenian digs that go back to the Bronze Age. Thus, we know the apricot was cultivated—or at least consumed—in that Central Asian crossroads in the period between 3600 and 1200 BC, the dates of the Bronze Age era.

Researchers have not found any apricot plants there that can be conclusively proved to be native. Nor have they found village names or any other place names there related to the apricot. This has led them to believe the apricot, though long cultivated in Armenia, is not a native Armenian plant.

The first written attribution anyone has found comes from the Emperor Yu in China, nearly five thousand years ago, as historian Robert Couchman notes, "The Chinese had a written character to represent the apricot in writings earlier than 2000 B.C."

Chinese writing is in logograms and pictograms. The Chinese symbol for apricot would bring a smile of recognition to the face of just about anyone who has ever eaten the fruit. The calligraphic symbol for apricot in Chinese? It is the symbol for a tree with an open mouth under it.

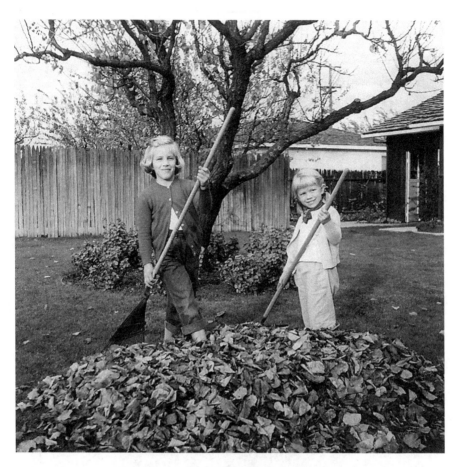

Apricot trees are deciduous, and the broad, flat leaves are a job to rake up. My sister (left) and I pose for one of our annual Christmas card pictures taken in our backyard during a break in our apricot leaf-raking chores. The leaves have a spicy scent to them that fills the air in the fall. *Chapman family collection.*

Following that charming linguistic trail leads to *xing* or *hszin*—the way the Chinese word for this tree-with-an-open-mouth-underneath-it symbol is written in English. There are at least eleven cities in China containing *xing* or *hszin* as part of their names. Because of this and because there appear to be wild or native apricot plants in China, pomologists believe the apricot may have originated there.

In some parts of China, the apricot is very different from the one cultivated in California. It doesn't have much in the way of fruit pulp on it and is produced for its seeds, which are used for seasoning—in the same way

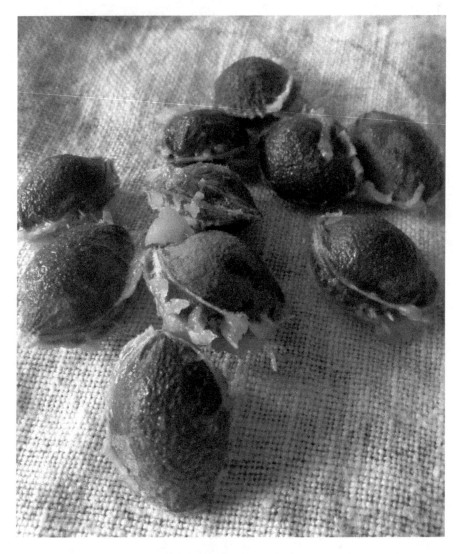

Apricots seeds are used like almonds in many parts of the world, for flavoring and for snacks. These come from the fresh apricots in the Chapman garden. *Photo by Robin Chapman.*

almond seeds are used—as well as for apricot oil and for food. But it isn't only in China that apricot seeds are used in this way. Anyone who has ever tasted the liqueur *amoretti di Saronno* has consumed a liqueur infused with the pits of the apricot.

In Central Asia, the apricot seeds are still a delicacy. My niece, Dana Moore McKnight, was a Peace Corps volunteer in Uzbekistan from 1999

to 2001 and was surprised to find apricots—which she had enjoyed at her grandparents' home in California—abundant in this isolated, former Soviet Socialist Republic. She wrote me:

> *There were tons of apricots in Uzbekistan—dried mostly, but they were made into compotes and jams and anything else that a person might do with an apricot. They also roasted and salted the pits, which we cracked and ate. They are a quite good little nut, like a cross between a pine nut and an almond. They aren't sold in the States because they contain some arsenic...but it must be a low level of arsenic as none of us died from eating them.*

It was in China that a man named Eugene Simon discovered the apricot plum (sometimes called a plumcot or a cotplum) and sent seeds home to France about 1872. Studies in the twentieth century of this apricot plum's chromosomes suggest it to be a hybrid. Still, the connection to China is intriguing.

There is also an ancient Japanese apricot (also seen in China) called *prunus mume*, the cultivation of which goes back many, many centuries. The tree is similar to *prunus armeniaca*, but both the leaves and the fruit are smaller. In Japan, it was the blossoms of this tree that were most admired, and they are often featured in Japanese art. But apricot blossoms have not only been the province of Japanese artists: Vincent Van Gogh painted a stunning apricot orchard in bloom at Arles, in the South of France, in 1888.

There are legends that Alexander the Great, in the fourth century BC, brought the apricot from Asia to Greece and that it then moved from there to Italy. Other tales say Marco Polo much later—in the thirteenth century AD—brought an apricot seedling from China to Italy. In their extensive research on the apricot, Janick, Faust, Surányi and Nyujtó have not been able to substantiate either of those tales. It does not mean there is no truth in them.

They do report on a debate that involves the apricot, King Solomon and the Bible. In Proverbs (25:11), the writer transcribes one of King Solomon's sayings as: "A word fitly spoken is like apples of gold in settings of silver." The Hebrew word used there is used again in several places in Song of Solomon (2:3, 7:8, 8:5). For example: "As the apple tree among the trees of the wood, so is my beloved among the sons."

In most editions of the Bible, the fruit involved is translated as "apple" in these passages. But one Michigan researcher suggests that "apricot" may be a better translation and has cited evidence of his own. The Song of Solomon

does refer to the fragrance and the sweetness of the fruit in question—which sounds more like an apricot than an apple. But this is mostly speculation. The search for the apricot within the layers of meaning in old King Solomon's words is perhaps best left behind in his ancient garden of metaphors.

It is certain that the modern word for the fruit of the apricot tree began to turn up in Italy in the papers of Roman writers in the first century AD. Robert Couchman, who grew up on a Santa Clara Valley farm, confirms this in his history of the California Prune and Apricot Growers: "Pliny, at about the time of Christ, mentions the apricot as a Roman fruit." Romans Lucius Licinius Lucullus and then Pompeius Magnus led legions into Armenia between 69 and 63 BC. They may have seen the fruit trees there, since it was after this that writers begin to list the fruit as a delicacy in Latin.

Plutarch writes that Lucullus retired to a villa in his old age where he produced fabulous meals from his Roman lands—thus the English word today "lucullan," meaning "rich and luxurious." In Lucullus's orchards, he introduced the lucullan sweetness of both the cherry and the apricot to the taste buds of Rome.

But the evidences of the travels of the apricot are many and varied. It appears the apricot meandered quite a bit on its journey westward.

There are at least three routes the apricot may have taken to the West, identified by researchers in the mid-twentieth century. If you set a globe down in front of you, you can trace them out, as Janick did in his *Origin and Dissemination of Prunus Crops*: "(1) the northern route from China to the Balkans; (2) the southern route from Armenia through Syria, Arabia, Greece, Italy, and northern Africa; later it was also spread into Russia; and (3) middle route distribution from the Danube valley to Germany. The Roman soldiers played a major role in this [last] distribution pattern, carrying the seeds/plants from place to place."

These routes are logical. The first is roughly equivalent to (though extends further than) the one Genghis Khan traveled with his Mongol conquests of the thirteenth century AD. The second route follows what was once the Silk Road. Apricots are believed to have been cultivated by the Sogdian traders who plied that route in the place they called Marakanda, which we call Samarkand. This could explain the origin of all those apricot pits the American Peace Corps volunteers munched on in Uzbekistan.

The third route to the West doesn't just follow the Roman legions. It follows the paths of just about all the invasions and wars of Europe that are traceable in recorded history.

A very old apricot tree in a valley garden. An indication of the age of this tree is the size of the damaged limb at photo center. It takes many decades for an apricot limb to get that big. *Photo by Robin Chapman.*

Some of the major researchers on the trail of the apricot are from Hungary, where the apricot is still cultivated today. Adam Gollner, for example, who moved to Montreal after the Iron Curtain fell, claims to have never eaten an apricot that compared to the ones he enjoyed as a teen in Hungary. His searches have led him "toward the vicinity of Uzbekistan, Tajikistan, and Kazakhstan. Russian botanist Nikolai Vavilov, before being sentenced to death [in the] Gulag, wrote of the myriad untamed apricots to be found in the foothills of the Tian Shan mountains; supernacular exemplars are known to grow near the city of Tashkent, founded upon the remains of Ming Uruk, which means 'A Thousand Apricot Trees.'"

Who would not want to live in a city with a name that means "A Thousand Apricot Trees"? Still, Uzbekistan was very likely just a way station in the apricot's route to Hungary. The Romans were in the region of Hungary

(they called it *Pannonia*) during the first century BC. In archaeological digs in Budapest, at the Roman city of Acquincum, researchers have found apricot seeds. So the tasty Hungarian 'cots may have arrived in Hungary from Italy via Roman roads instead of from Ming Uruk. Or, as is likely, the trees may have come to Hungary more than once, by more than one route.

The apricot was certainly also brought to Eastern Europe by the Turks, who, like the Egyptians, have cultivated apricots for many centuries. Now that the Santa Clara Valley is no longer a center of apricot production, quite a few of the dried apricots found in American grocery stores today come from Turkey. This is not something that is at all popular with the Apricot Producers of California, a group which now harvests most of its crop in the Golden State's San Joaquin Valley.

But long before a modern trade deal brought the Turkish apricot to America, the Ottoman Turkish Empire was moving the apricot about. During its six hundred years of conquest and consolidation, beginning in the thirteenth century AD, the Ottoman Empire's power reached into Northern Africa and almost as far west as Vienna. "Even today, in Hungary," writes pomologist Jules Janick, "the present centers of apricot production clearly overlap with the 17th century location of Turkish estates of the Sultan…[and] the Hungarian word for apricot, *kajszi*, has a Turkish origin."

It was another Arabic culture that brought the apricot to Spain, "likely during the regime of the Umayyads (661–750), who conquered Spain between 711 and 719," writes Janick. Since the apricot came to Mexico and California from Spain, this is the next turn in the road to follow.

Several Arabic writers in the early Middle Ages mention the cultivation of the apricot in the Spanish region of Andalusia, where the mildness of the climate was good for apricot growing. The word they used in Arabic for apricot, *al-burquq*—which can also mean "plum"—suggests another possible origin for the English word "apricot." (Try saying the Arabic word quickly, and you'll note the similarity.) To complicate things even further, some Spanish and Portuguese speakers today call the apricot *damasco*—a Spanish version of the name of the capital of Syria.

This also recalls an old Arab saying: "The only thing better—is an apricot in Damascus." That is a rough equivalent to the modern words: "It just doesn't get any better than this."

Ultimately, researchers believe there were several different kinds of apricot cultivars that entered Europe and then the Americas by the several routes mentioned above. This likely led to the best traits in the trees we grow today. One apricot type came from Central Asia and Turkey through Central

These are Patterson apricots developed in California and grown in the Central Valley. Lighter in color and larger in size than the Blenheim that predominated in the Santa Clara Valley, the Patterson nevertheless has a great flavor. *Photo by Robin Chapman.*

Europe and Hungary and then moved into France. Because the climate of Hungary is too cold for drying, this cultivar produced a large apricot that ripened into a superb fresh fruit.

Another cultivar came from North Africa into Spain and produced a line of descendants from an apricot called the Canino. This may be the forefather of the first seedlings brought with the Spanish to Mexico and thence to California. Though nurseries would later introduce many other French and English apricot hybrids into California, including the popular Blenheim, it was probably the descendants of the Canino that first entered the mission gardens.

So it isn't surprising that this particular strain of the apricot would show early promise in California. These Spanish apricot cultivars had been moved

to a climate that was very similar to that of Spain but was, in some ways, even better. Edward Wickson points out, in the Santa Clara Valley, there was an almost perfect symbiosis between what the apricot needed and what the valley had to offer:

> [I]t is close to the ocean but moderated from it by San Francisco Bay on one side and the Coast Range on the other. So it does not have the heat of the interior valleys or the potential for frost...The air...has a clearness and brilliance from its aridity which makes each day of the long, growing season more than a day in other climates, and thus adds to the calendar length of the growing season. The surplus light and heat also act directly in the chemistry which proceeds in the tissues of the plant, and we have not only size, but quality, color, aroma—everything which makes the perfect fruit precious and beautiful beyond words.

This explains why the apricot was destined to thrive in the Santa Clara Valley. All the elements combined to make the environment ideal for this variety of *prunus*. It had been tried in many places. It had come west by many routes. It was carried by many hands from many cultures through the centuries and across the globe.

After such a winding road, it is remarkable that the apricot found its largest commercial success so far away from the ancient lands of its birth.

But that is exactly what happened.

Apricots and the Amazing Century

Lowering my eyes, I catch the full beauty of the apricot trees, dressed in their snowy
white blossoms. Drawing a deep breath, I fill my nostrils with the heavenly scent.
—*Lyle W. Job Huestis*

The nineteenth century was an astonishing one for California. The changes that came to the state were enormous. Without them, the orchards of the Santa Clara Valley would not have blossomed as they did, nor fed so many people around the world.

What happened were revolutions in California's geopolitical status, population, economy, technology and transportation systems. All these things came together to transform the state and the Santa Clara Valley, creating a new environment in which orchards could flourish. No one factor alone was responsible, and none is easily parted from the others. All rolled together like a giant rockslide, changing everything in its path. Once the dust had settled in the Santa Clara Valley, there were millions of apricot and fruit trees of all varieties.

When the century began, a handful of Franciscan padres struggled to do the work of their order at missions scattered along California's El Camino Real. Thousands of Indian men still traveled the land, fishing and hunting for their families. Fruit trees were rare and flourished in just a few isolated mission gardens.

At the century's close, most of the Spanish missions were abandoned. The Indians, as Santa Clara County historian Ralph Rambo put it, "had been

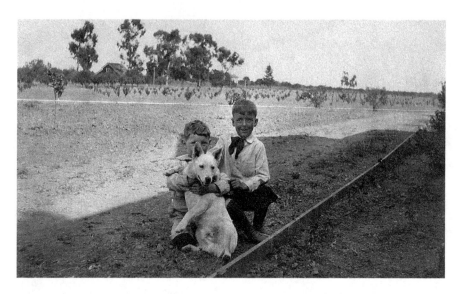

Burrell Leonard (at left with his dog) and his friend Arthur Will pose in front of a newly planted apricot orchard in Cupertino, in the early twentieth century. Burrell Leonard inherited more than two hundred acres of orchard land in the valley, where he grew apricots under his father John Leonard's label. *Courtesy of History San Jose.*

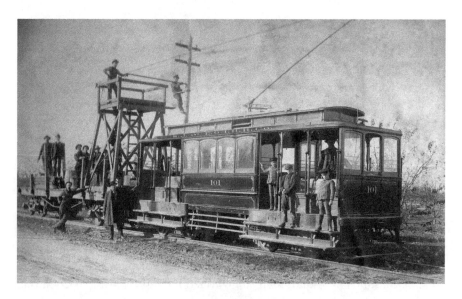

The San Jose–Los Gatos Interurban Rail Road during its construction in about 1902. Trains and trolleys are a magnet for children, and three of them have appeared to pose here. Two boys are dressed up and may have come with one of the officials of the line. The boy in overalls may have raced over from a nearby orchard. *Courtesy of History San Jose.*

roughly pushed aside." Growers in the state of California had an annual apricot harvest in the 1890s that was close to three million pounds.

By the last decade of the nineteenth century, there were electric lights and streetcars in towns like San Jose and Santa Clara. Millions of pounds of dried and fresh fruit were headed east on the railroads, and anyone with the price of a ticket could take a train west to California, as the writer Robert Louis Stevenson did in 1879.

Stevenson was a thoughtful traveler. In writings uncovered by Kimbro and Costello, he bemoans the fate of the old mission in Carmel, which he visited on his journey. "You have there a church of extreme interest which is going the way of all roofless and neglected buildings...The United States Mint can coin many million more dollar pieces, but not make a single Indian; and when Carmel Church is in dust, not all the wealth of all the States and Territories can replace what has been lost."

What Stevenson saw in Carmel was the result of just a few decades of California's transformation. In a very short amount of time, theses changes took California from a rural outpost of Spain to a neglected province of Mexico, to an independent Bear Flag Republic (however briefly), to a Territory of and then a state in the United States. All these things moved California into a position to become a world leader in agriculture.

The shifting status of California and the independence of Mexico from Spain brought about the breakup of the missions. The breakup of the missions led to millions of acres of land moving from the hands of the few to the hands of quite a few more.

All this took place as the Industrial Revolution was transforming the nations of Europe and their former colonies. This amazing leap in the use of machines meant fewer people could work more land, something historian J.P. Munro-Fraser noted in his history of Santa Clara County in 1881: "The great extent of level land in this valley admits of the use of all descriptions of agricultural machinery; the consequence is that nearly all the work on the large farms is performed with almost incredible rapidity. A thousand acres are sometimes plowed, seeded and cut in less time than is required on farms of one hundred acres in many parts of Europe."

The Santa Clara Valley became home to some of the nation's early innovative foundries producing agricultural machinery. Among them was the Knapp Plow Works of San Jose. Turning a plow around at the end of a furrow could be difficult, especially on a hillside, in the days when plows were pulled by teams of horses. There were reversible plows in the nineteenth century, but Robert I. Knapp improved the design and the Knapp Reversible

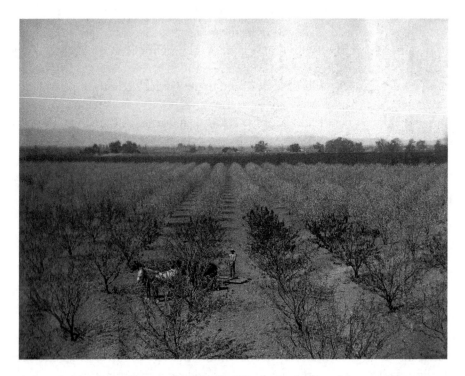

A view of a large orchard between Los Gatos and San Jose at the turn of the twentieth century. If you look carefully, you can see that the orchard is in transition between blossoms and leaves. The owner, with a team of horses and wooden sled, is at center. *Courtesy of History San Jose.*

Plow was produced and sold in the Santa Clara Valley, beginning in the nineteenth century, and shipped all over the world. There is one today in the Smithsonian Institution.

Trains and electric trollies meant more people could travel more miles in fewer hours. Fragile commodities like apricots could now be transported more quickly from field to table, opening up enormous new markets for California. As researcher Sally Richards discovered in her search for Santa Clara County's innovative roots, "People continued to flood into the Valley and change every aspect of life as the indigenous people and settlers knew it…It's often said that where a community's population is growing substantially, and technology is needed to supply greater amounts of goods…technology grows the fastest."

By the end of the nineteenth century, machines for canning, drying, picking, packaging and box making joined with railroads and steamships to make it more efficient to operate a small orchard and more likely that a family could turn a profit with one.

Writers like Mary H. Wills followed Robert Louis Stevenson, visiting California in 1888–89 and saw the beginnings of agriculture and orchards in the Santa Clara River Valley: "The country is low and flat, much of it uncultivated, and all for sale. Some newly planted orange groves and apricot trees are seen, as well as vast fields of mammoth cabbage and beet gardens. The road leaves the main line at Saugus and descends through the lovely valley of Santa Clara…"

Pioneer trails preceded the railroads, and they, too, began to have an impact on California's tiny population. More people would squabble over its acreage. More would work in competition with one another in its businesses. There were more mouths to feed.

The discovery of gold in 1849 brought wealth to the state and a big jump in population. The influx of miners created greater markets in California for food. Many failed miners stayed and started businesses or bought land and cultivated it. According to Couchman in *The Sunsweet Story*, "The first extensive new plantings of fruit trees tended to be in the Santa Clara Valley, mainly because of the long existence there of the widely known secular community, the pueblo of San Jose. The orchards of the nearby Missions of Santa Clara and San Jose demonstrated the favorable growing conditions of the Valley—fertile soil, the mild and semi-arid climate and abundant water."

The westward movement across the continent had begun soon after the early European settlers landed in North America. It gained momentum in 1804 when Thomas Jefferson sent Meriwether Lewis and William Clark on the first American transcontinental expedition. They returned from the Pacific Northwest in 1806, carrying with them hundreds of new maps and reports of the West's vast land and beauty. From that moment, the idea of uniting the States from one coast to the other captured the American imagination.

California saw the beginning of these changes in the first few decades of the nineteenth century when, in 1826–27, mountain man Jedediah Smith became the first American to enter California by land: in his case, through the desert from the south. He was first welcomed in Southern California with kindness by the Mexican authorities and then put in jail, since he had entered the state without the permission of the Mexican government. Resident Americans, who had taken Mexican citizenship so they could own ranches in California, took up Smith's case. He was released and told to go back the way he had come.

Smith didn't follow these instructions, nor did he stop trapping, as he had been ordered. Instead, he spent several productive months bagging game in

the San Joaquin Valley—a harvest of his own of California's native fauna. He then hiked into the Sierras to become the first American to find a path through those mountains from California, eastward. He told his fellow trappers, at the next rendezvous, what he had seen in California—and spreading the word among these intrepid mountain men ensured that the news got around.

He returned the following season and was welcomed somewhat less warmly by California authorities. Again he was tossed in the calaboose. Again he was released on a sort of parole. This time he hiked back into the United States by way of the Oregon Territory—another first. Smith had slipped through a chink in the wall that kept California isolated, and the pioneers that followed him began to barrel through behind him.

Men like Christopher "Kit" Carson and Santa Clara County pioneer Elisha Stephens found paths through the Sierras and brought along pioneers with wagons and families and farm machinery. It all represented too much change coming far too quickly for many of the old-timers who liked California the way it was—at least, the way it had been since the padres arrived and made their own set of changes.

As writer Dale Walker tells the tale, one of the last Mexican governors of California, Pío de Jesús Pico, looked around in the 1840s and wrote authorities in Mexico City, "We are threatened by hordes of Yankee emigrants; already the wagons of these perfidious people have scaled the almost inaccessible summits of the Sierra Nevadas, crossed the entire continent and penetrated the fruitful valley of the Sacramento. They are cultivating farms, establishing vineyards, erecting mills, sawing up lumber, building workshops and a thousand and one things which seem natural to them but which Californians neglect or despise—we cannot stand alone against them."

It was the *cultivating* that especially seemed to grate on the *Californios*. Their lives had been quite happy without all that enterprise. Since the eighteenth century, the *rancheros* had let their cattle roam the unfenced land. When they needed money, they rounded them up and took what they needed for hides and tallow.

Pico, whose grandfather had served on the Anza expedition and who had been born in California in 1801, lived long enough to find that he, too, was a Yankee—or if not a Yankee in spirit, at least a citizen of the United States by law. In 1893, a year before his death, some Los Angeles businessmen asked the elder statesman to appear at the World's Columbian Exposition in Chicago as a representative of "the last of the dons." He was having none of it. Remaining at his daughter's home near Los Angeles, he reportedly

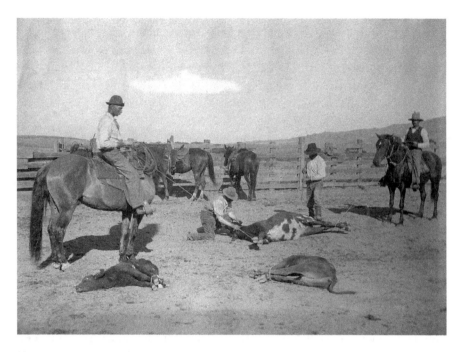

Until the last decades of the nineteenth century, cattle and grain production still predominated in the Santa Clara Valley. This photo is of a ranch outside San Jose during the valley's transition from pastureland to orchards. The cowboys were often descendants of California Indians. *Courtesy of History San Jose.*

said, "If those gringos imagine for a moment they can take me back there and show me in a side tent at two bits a head, they are very mistaken."

His younger brother adapted more easily. Andrés Pico, after fighting as a soldier against the American takeover, settled down to serve in the new state legislature. At home, he cultivated apricots and other fruit in orchards that had once belonged to Mission San Fernando.

The Mexican government, perhaps to the surprise of all the Picos, aided in this reversal of its own fortunes.

First, after the Mexican people succeeded in their War of Independence from Spain, California was recognized only as a territory (called a *departmento*) of Mexico. The Mexican government did this because California had a small population, and it had larger problems to contend with closer to home. California's distance from Mexico City, and the benign neglect of this policy, left the Californios time to think of themselves as independent of outside rule.

Then the Mexican government's secularization of the missions opened up the mission lands to development. These historic compounds were ordered to become parish churches, not large ranchos with outposts of soul saving at their center. Only a few of the missions survived, as Robert Louis Stevenson noted. Most of the padres went home to Mexico or sailed back to Spain and were not replaced. Mission Indians scattered.

For California, this meant that the vast mission lands became part of the public domain or were awarded as land grants and homesteads to veteran soldiers and pioneers. California land, as Santa Clara County historian Clyde Arbuckle points out, was at last available: "Mexican land laws virtually opened the field to all comers. Any reputable Mexican citizen had little more to do than file an *espediente* and *diseño* (petition and crude map) for the land he desired. This simple process, costing about $12, could obtain for him anything from a house lot a few feet square to a rancho of 11 square leagues (48,818 acres)."

All comers did not exclude California Indians, though the number of Indians awarded land grants by the Mexican government was small. In Santa Clara County, only four members of California's native groups owned a rancho or a piece of a rancho in a valley where there were at least forty of these large land grants. An Indian called Yñigo was given title to Rancho Posolmi in 1844. The property covered about 1,695 acres in the area where Moffett Field stands today.

Santa Clara de Asís was the last mission to be secularized and was then turned over to the Jesuits for a college. Because of this, it didn't suffer quite as much from neglect as did some of the others. But its status as one of the last of the functioning missions did give its final Franciscan padre the opportunity to cause a little scandal.

He was Father José María del Refugio Sagrado Suarez del Real, and before he signed the mission over, he deeded several of its buildings to his mistress, a woman named Candelaria, with whom he had several children. She had her own form of land cultivation in mind, turning one of the buildings he gave her into a popular fandango parlor during the Gold Rush. (The Jesuits later had to buy it back from her.) Meanwhile, the padre headed up to the gold fields—some said to minister to the miners; others, more skeptical, guessed he was just going to try his luck with the rest of the folks.

Mission San Jose and Mission Santa Clara were, after Sutter's Fort, the first signs of European civilization many pioneers came upon when they made it over the Sierras. Journalist Edwin Bryant arrived at Mission San Jose in September 1846, ahead of the ill-fated Donner Party. One of the first

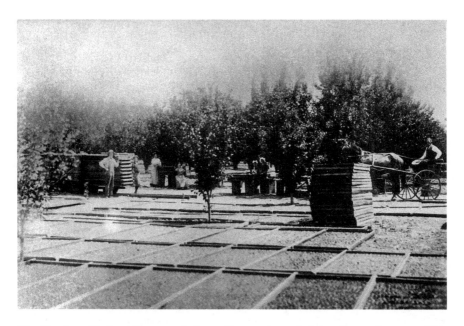

The Goodacre Orchard Company in Santa Clara at the end of the nineteenth century. This is a small family operation, with the men doing the hauling and the women, wearing their summer dresses, doing the apricot cutting. The photo is a century old, but looking at it, you can almost feel the summer sunlight. *Courtesy of History San Jose.*

things he noticed, reports Edward Wickson, was something travelers didn't see much of in those days: "Bryant found at the Mission…two gardens enclosed by high adobe walls. The area was from fifteen to twenty acres all of which was planted with fruit trees and vines."

At the time Bryant saw the orchards, there were only about eight thousand Spanish, Mexican, European and American men and women in Alta California. Of the eighty-seven thousand Indians whom historian Dale Walker calculates had been taken in by the missions, only about eight thousand lived to see the middle of the nineteenth century.

This tiny population began to grow in 1846—the same year Bryant arrived—when nearly three thousand pioneers made it into California through its southern deserts and over its mountain passes. That was just a boomlet compared with what happened next.

On January 24, 1848, a man called James Marshall discovered gold at the sawmill on the Northern California property of John Sutter. One of the many results of that discovery was that in 1849, ninety thousand people flooded into California, which had just become a Territory of the United

States. By 1852, the number of immigrants to California had risen to a quarter of a million.

California was so rich in plant life and game that almost none of the newcomers went hungry. On one of Kit Carson's expeditions, he claims he found so many trout in a stream on the western slope of the Sierras, he and his men kicked the fish to the bank and cooked them for dinner. (If you weren't there, it was pretty hard to call an armed man like Kit Carson a liar.)

Luxuries like eggs, milk, fruits and vegetables, on the other hand, were so difficult to obtain, they became almost as valuable as gold. In *The California Fruits and How to Grow Them*, Edward Wickson describes what happened next: "After the incoming of the Americans in 1849, some of the old Mission trees were secured by enterprising men ... that they might minister to the great demand for fruit which sprang up among the gold seekers."

The fruit included vineyards located where the Santa Clara University's Varsi Library now stands. The mission orchard was across the street. How these men "secured" the fruit is not reported. Squatters often just parked themselves on land in those days and stayed—unless or until someone pulled out a gun and ordered them out. In the period between 1846, when the first pioneers came in large numbers, and 1850, when California was admitted to the union, the region was in a kind of legal chaos. It is likely that the "enterprising fellows" simply picked the fruit in the neglected mission gardens and hauled it away to make a tidy profit.

This wasn't unprecedented. Pioneers who made it over the Sierras were encouraged by John C. Frémont—a leader of the Bear Flag Revolt—to stay at what he called the "mostly unoccupied" missions. And though Mission Santa Clara was still mostly occupied (by its last padre, the lively Father Suarez del Real), so many pioneers squatted in a warehouse at the mission that it earned the nickname "The California Hotel."

The newcomers were all astonished by California's climate. They knew the snowy winters and humid summers of the East and Midwest. California was something very different. Those who experienced it for the first time, as J.P. Munro-Fraser did in 1881, had a tendency to rave: "These lengthy, dry Summers are truly the perfection of this climate...The nights are positively sublime. Invariably cool enough to require thick covering, sleep becomes a luxury rarely enjoyed in other lands. It is this peculiarity of climate that gives such perfection to the cereals, such luster and lusciousness to the Summer fruits produced in the Santa Clara valley."

Robert F. Stockton, who played a key role in California statehood, was from New Jersey and found himself intrigued by the climate of this

new land. He served as commander of the American naval forces who took possession of California in 1846 and a year later bought a ranch in the Santa Clara Valley. Rancho El Potrero de Santa Clara (St. Clare's Horse—or Colt—Farm) was small by California standards of the time: it was just under two thousand acres. It had been mission land and was wedged between Mission Santa Clara and the village of San Jose.

Stockton did some early grafting using mission fruit trees. Then, in 1852, he brought in apple, peach, pear, nectarine and apricot rootstock from the East so he could set up one of the first nurseries in the region. Researching the history of Santa Clara, Garcia, Giacomini and Goodfellow uncovered Stockton's first sales circular:

> *Fruit Trees at Auction! 5,000 Fruit Trees from Two to Three Years old will be offered for sale at auction on the 19th December at 10 o'clock, A.M., on the Stockton Rancho, on the Almaden, or road leading from the city of San Jose to Santa Clara, Santa Clara County. Those wishing to purchase large, healthy and vigorous trees will do well to call and look at these trees before purchasing elsewhere as they are all positively to be sold...4,000 Apricot Trees, two years old, several of the choicest varieties, and will bear the coming season if carefully transplanted. Terms, Cash on Day of Sale. Jas F. Kennedy, Agent.*

Stockton's nursery sale was just one more of the factors that led to Santa Clara Valley's transformation from a land of grain and cattle to a valley fill with orchards. According to California historian Hubert Bancroft, "Agricultural development along American lines quickly began. Impressed by the productivity of the Mission's orchards, some farmers [experimented] with these on land they had intended for wheat farms."

Before real growth could occur, California had to get its legal issues sorted out. The U.S. Senate created the Public Land Commission in 1851 to review the tangle of land title cases in the new state. Between Spanish land grants, Mexican land grants, mission lands, Native American issues, squatters, homesteaders and titles of dubious value that had been bought and sold during the Gold Rush, California was awash in disputes. In the rough and ready days of the miners, ranches could be won and lost at the poker tables during games well lubricated by adult beverages.

It got so bad in the Santa Clara Valley that the women of the Berryessa family kept water boiling on the stove (to scald poachers) and wore knives on their belts, just in case further discouragement was necessary. The Berryessas

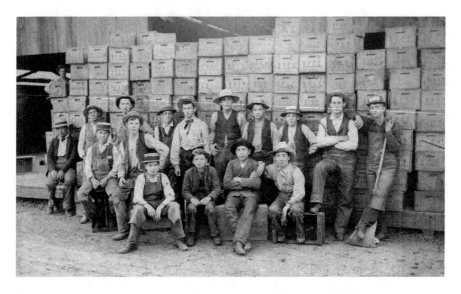

The Berryessas may have lost out to the Alvisos, but the Berryessa Fruit District carried their name. Here, some tough-looking shed boys pose at the Berryessa Fruit Growers Union in 1890. Shed boys hauled boxes of fruit and drying trays and could work as many as eighty-five hours a week during the fruit season. *Courtesy of History San Jose.*

were fighting at the time with the Alvisos over Rancho Milpitas. The boiling water and the knives-at-the-ready were not enough: the courts found in favor of Alviso and his heirs.

The development of the valley's orchards began to accelerate in the decade following the Gold Rush. In her history of Silicon Valley, Sally Richards records the differences writer Bayard Taylor observed between his first visit to California in 1849 and his second a decade later: "As we drove along it, I looked in vain for the open plain, covered with its giant growth of wild mustard. The town (San Jose) now lies imbedded in orchards, over whose low level green rise the majestic forms of the sycamore, which marks the course of the stream…"

By 1868, when John Muir hiked from Oakland to San Jose, he noted the agricultural features on the landscape of the Santa Clara Valley. "Its rich bottoms are filled with wheatfields and orchards," he wrote in his journal.

The orchards, as they changed with the seasons, became another aspect of California to admire. Helen Hunt Jackson seems to have had them on her mind after her trip to California as she sat in a New York hotel room during the chilly winter of 1883–84, penning the novel *Ramona*. She mentions the orchards many times in her tale: "The almonds had bloomed and the

blossoms fallen; the apricots also, and the peaches and pears; on all the orchards of these fruits had come a filmy tint of green, so light it was hardly more than a shadow on the gray."

The completion of the transcontinental railroad was an essential part of the growth of the orchard business. When that linked the two coasts in 1869, it created an economic and social earthquake for the new state. California, a sort of fabled land, could now be reached by riding the iron horse. Produce began heading east and passengers began coming west.

(Even Abraham Lincoln confessed near the end of his life that he'd like to see California, when the railroad was completed. He may have heard tales about California from several men he knew well. William Tecumseh Sherman served in California during the American takeover in 1847. Mrs. Lincoln's nephew, William L. Todd, also played a part in California statehood and is given credit for designing the California flag—later hauled down and replaced with the Stars and Stripes by U.S. Navy Lieutenant Joseph Warren Revere, Paul Revere's grandson.)

For orchardists, the railroads changed everything. L.A. Gould, who had an orchard at Scott Lane and El Camino in Santa Clara, shipped the first load of fresh fruit east on the train in 1869. The United States population was approaching forty million: there was now a means for California growers to move produce quickly to the growing nation. Santa Clara Valley writer Yvonne Jacobson's family arrived in the valley just after this period. "Before long," she writes, "luscious fruits from Santa Clara County would enhance the diets and tables of people in New York and Boston, Philadelphia and Minneapolis. More and more partook of the feast, making fruit orchards economic and allowing a unique pattern of small family farms to emerge in Santa Clara County."

Other accidents of history nurtured orchard growth. A century of grain production in the valley had caused soil depletion that required a change of crops. This coincided with the settling of many of the land cases. Those two factors intersected with the rise in land values brought about by opening of the railroad. The rise in land values led to higher property taxes and that gave large ranch owners a motivation to sell off pieces of their land. The average size of a farm in California was more than 4,000 acres in 1850: by 1900, that had dropped to just 397 acres. Historians like J.P. Munro-Fraser visited the Santa Clara Valley when it was on the cusp of its striking transition from growing grain to cultivating fruit trees:

Perhaps only a true lover of apricot cultivation would take a picture of his trees in winter and take pride in their appearance. Grower Burrell Leonard of Cupertino did just that and under the photo wrote: "Trees are just starting their 31ˢᵗ growing season. They have been trimmed back to hold this desirable size for about fifteen years." *Courtesy of History San Jose.*

The farmers' houses, surrounded by garden and orchards, appear like beautiful green islands in a golden sea. A month later the whole scene is changed: the waving grain has all been cut, and huge stacks of yellow straw...are piled up in all directions...In the Spring, it presents still another aspect, when the young grain is just peering above the black soil, and the purple and white blossoms of the apricot and peach form a striking contrast in color with the hazy neutral tint of the distant mountains.

In 1898, just seventeen years after Munro-Fraser wrote those words, the Santa Clara Valley was planted with millions of fruit trees.

For many years to come, apricot trees and prune trees would fill the greatest number of valley acres. The success of the finicky apricot surprised even the experts, like Wickson, who wrote in 1914:

California has...apricot trees which stand in the open air without protection of any kind and bear large, luscious fruit. That apricot trees can do this

constitutes one of the unique features of California fruit growing and proclaims it different from fruit growing in other States, for excepting a few localities in other parts of the Pacific slope, California has a monopoly of commercial apricot growing and nowhere else in the world does the fruit attain such commercial importance. The tree is generally regarded as one of the healthiest and most vigorous, as it certainly is one of our most beautiful orchard trees.

By the end of the nineteenth century and the beginning of the twentieth, people like Carl and Hannah Olson were buying small farms surrounding country stores in places like Sunnyvale, Saratoga, Cupertino, Campbell, Los Gatos, Mountain View, Los Altos and Santa Clara. Apricot trees were thriving. There were profits to be made in the valley's orchards.

CHAPTER 4

Apricot Acreage

I had a job picking 'cots for twenty cents a bucket in 1965 near where I-280 and El Monte Road are now. We used to dry them in our own yard, too, on trays my father dug up from somewhere. So good.
—*Socrates Peter Manoukian*

The men and women who came to this fertile valley and began to cultivate it came for many different reasons. Some sought prosperity they could not find at home. Some sought freedom and the independence to run their own businesses. The beauty of the land between the Coast Range and San Francisco Bay attracted many. According to Richards in her book *Silicon Valley*: "The Gold Rush had brought a flood of immigrants to California, many of whom traveled west from the Sierra foothills into the Valley after their mining dreams went bust. Many of the Valley's new residents came from the warmer regions of Europe, whose climates were very near to that of their new home. Recognizing a good opportunity, they began planting trees indigenous to their homelands; their fruit orchards would soon produce some of the finest, sweetest crops ever."

Among the first to settle into the orchard business were E.W. Case, William Daniels and Joseph Aram. Case's orchard was in Alviso. Aram and Daniels chose acreage that was inside what are now the city limits of San Jose. They acquired cuttings to start their orchards from a pioneer who brought them overland from Ohio and sent away for more seedlings from the Charles Hovey Nursery in Massachusetts.

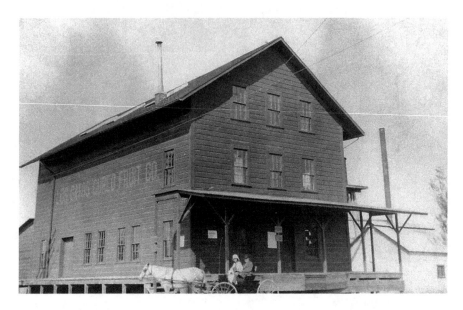

This is the Los Gatos Cured Fruit Company in 1914, which was located near the corner of Los Gatos and Almaden Roads in San Jose. Miss Ester Bartley and Mr. Fred Erdman pose during an outing to the building where apricots under the Blue Steel brand were packed. *Courtesy of History San Jose.*

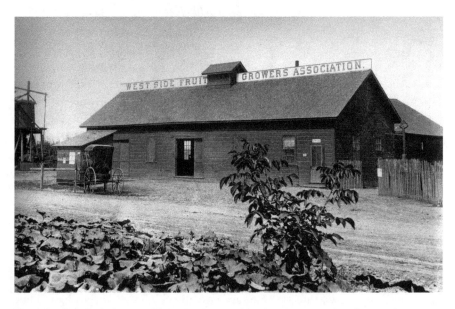

The West Side Fruit Growers Union in about 1900, when it operated on Stevens Creek Road in Cupertino. Growers could join a growers union and use the cooperative for their drying operations. It looks like someone has planted squash in the front garden along with a peach seedling. *Courtesy of History San Jose.*

A man named D.C. Vestal had an orchard on Twelfth Street in San Jose in the 1850s. It was Vestal, according to historian Eugene Sawyer, who first developed the Moorpark apricot: "George Hobson...had two of these [Moorpark apricot] trees, but held them in little estimation on account of their irregularity in ripening. From these trees Vestal procured buds and worked them into a few trees on his place. When the fruit appeared he was so greatly pleased with its size and flavor that, in 1869, he planted three acres. His experiments attracted attention and the Moorpark came into universal favor."

Commodore Robert F. Stockton's sale of orchard trees in 1852 was a big contribution to the business. And yet he eventually returned to his home state of New Jersey. Elisha Stephens gave the orchard business a try as well. Though he is best remembered today for the misspelling of his name in Stevens Creek and Stevens Creek Boulevard, Elisha Stephens was, according to historian Ralph Rambo, the first English-speaking American settler in the western part of Santa Clara Valley. He was also one of the earliest who cultivated an orchard.

Stephens was the guide who brought the Murphy-Townsend party over the Sierras in 1844–45, the first wagon train that made it safely over that difficult route. Afterward, he wandered California for four years, finally settling on Blackberry Farm in what is now Cupertino—just west of Monte Vista. On that land and another parcel of 155 acres he acquired later, he planted berries, grapes and fruit trees. He became known for attracting a wide array of eccentrics to his farm, from a one-legged trapper called Peg Leg Smith, to a spiritualist who gave séances, to two brothers who invented (or tried to invent) perpetual motion machines. He also surprised his neighbors by hiring Indians to tend his orchard, because, he said, they understood a lot about the fruit trees.

In 1864, with the population of the Santa Clara Valley approaching eleven thousand, he decided things were getting a little too crowded. He sold his 315.57 acres and moved to Kern County, where, like Sherlock Holmes, he retired to beekeeping. The wagon he had brought with him across the Sierras went to his old friend Frank Grant—who gave his name to Grant Road. The old wagon, says Ralph Rambo "was allowed to rot away until only the iron was left," a symbol of changing times.

Bernard Fox, born in Ireland, arrived in the valley to shepherd the nursery shipment of Robert F. Stockton's trees in 1852. Shortly afterward, Fox established his own nursery business, three miles outside San Jose on the Milpitas Road. Though he called the place the Santa Clara Valley Nurseries

and Botanical Gardens, most locals just called it the Fox Nursery. It became one of the first on the West Coast to regularly import and sell fruit trees.

When Bernard Fox died, his nephew R.D. Fox inherited the business and, with John Rock, started the California Nursery Company, first located at Wayne Station in San Jose. Then, in 1884, the two men purchased five hundred acres just across the county line near the Alameda village of Niles. It was not far from the orchards that had once flourished on the land of Mission San Jose. The California Nursery Company became the largest on the West Coast exclusively devoted to fruit trees. Yvonne Jacobson, of the Olson orchard family of Sunnyvale, describes the nursery as an astonishing place in wild California: "A grower could choose from four hundred varieties of apples alone. Rock also specialized in prunes (he introduced the Imperial), peaches, apricots, plums, and cherries—a total of 1600 varieties of fruit trees by 1884."

The Murphys, whom Elisha Stephens brought over the Sierras, became so successful in the valley that at one time their holdings stretched for seventy thousand acres or just under 10 percent of the entire valley. Their land included: Rancho La Polka near Gilroy (reportedly named for Mr. Murphy's favorite dance); Ojo de Agua de la Coche (Pig Spring Rancho) near the present-day Morgan Hill; the twenty-two-thousand-acre San Francisco de la Llagas (St. Francis of the Wounds) between Morgan Hill and Gilroy; and Pastoría de las Borregas (Lamb Pasture Ranch), which covered most of what is now Mountain View and Sunnyvale.

Along with others of the mid-nineteenth century pioneers, the Murphys raised mostly cattle and grain, though on their Sunnyvale property they did plant an orchard. Later Murphy generations, uninterested in ranching, sold off the land to small farmers. The family gave its name to the town of Murphy Station, a little burg later known as Sunnyvale, where one can still find Murphy Avenue.

It was on old Murphy land in Sunnyvale that Swedish immigrants Carl Johan Olson and his wife, Hannah, bought their first five acres of orchard land, for $150 an acre, at the end of the nineteenth century. Though they later became best known for their cherries, several generations of Olsons also specialized in other *prunus* crops, including apricots, on their orchards adjacent to El Camino Real.

El Camino Real, at the end of the nineteenth century, was not exactly regal and definitely not much of a highway. It was a dirt and gravel obstacle course that connected the little towns on the Peninsula with San Francisco and connected the Santa Clara Valley farms and orchards. "I recall having

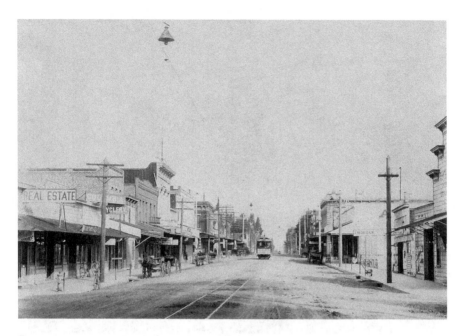

Everything was up to date in Santa Clara, as you can see from this photo, circa 1900. The downtown has a trolley and electric lights and seems to have more than one cyclist. But Franklin Street is not yet paved. Paved roads came later with the advent of the automobile. *Courtesy of History San Jose.*

our wagon stuck in a mud hole going through what is now Barron Park to Palo Alto," Mrs. M.O. Adams told an interviewer in the 1950s. The Adams grew apricots on their orchard land in Los Altos.

There is a good reason many of the orchards were near or fronted on El Camino. Fruit was transported in wagons pulled by horses then, and El Camino Real, even at its worst, was one of the best roads in the valley. In 1912, beginning in San Mateo County, it also became the first paved highway in the San Francisco Bay Area.

Carl and Hannah Olson of Sunnyvale started one of the few fruit businesses in the valley that would survive into the twenty-first century. One branch of the family still operates the historic fruit stand at 348 West El Camino Real, Sunnyvale, not far from the land where the Olson orchards once grew. On their advertising, they state with pride, "Same location since 1899."

The 1880s and 1890s were a fertile time for orchard planting in the Santa Clara Valley. The growth was swift, as Eugene Sawyer describes in his 1921 county history. "During the eighties the fruit industry increased by leaps and bounds, vineyards, pasture and grain lands were converted into

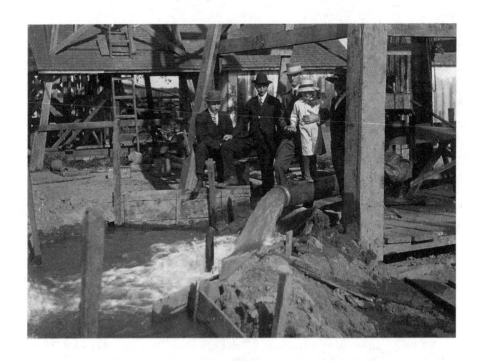

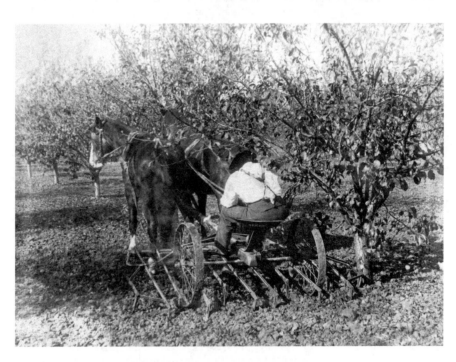

fruit orchards until the county became one vast orchard—the largest fruit producing section in the world."

It was almost as if the valley had a richness waiting to be mined. For one thing, the Santa Clara Valley has remarkable alluvial soil, some of the deepest and richest measured anywhere in the world. For eons, rains have been washing loam from the mountains into the valley, where it has gathered, layer upon layer, as the winter rains flow into San Francisco Bay. Though a few parts of the valley have rock-hard adobe soil and a few parts were (in the nineteenth century) covered in salty marshes, most of the Santa Clara Valley features the richest, deepest topsoil found almost anywhere.

The valley also had a plentiful supply of water in its artesian wells. This helped farmers and their orchards survive the long, dry summers. For, as botanist Mary Elizabeth Parsons observed in 1902, "The climate of California is divided into two seasons—the wet and the dry—, the former extending from October to May, the latter occupying the remaining months of the year...Instead of shrouding the earth in snow during our period of plant-rest, as she does in more rigorous climes, Nature gently spreads over hill and valley a soft mantle of brown."

The first artesian well was dug by the Merritt Brothers, in 1854, right in downtown San Jose. One early well flooded San Jose's streets for days, until a means was found to control its flow. By 1881, more than one thousand artesian wells were operating in the county. One local newsman, quoted by J.P. Munro-Fraser, gushed about this new discovery: "What a change! What a wealth for this beautiful valley! Far beyond the value of the discovery of a dozen gold mines; it appeared the work of enchantment...All had felt that water for irrigation and good water for drinking were the great necessaries of this lovely valley."

Opposite, top: Artesian wells were a huge asset to growers. This one being tested in 1915 was operated by steam power until electricity became available. It produced enough water for the operation of a fifty-acre apricot orchard and continued to produce into the 1980s. You can see the apricot orchard in the background. *Courtesy of History San Jose.*

Opposite, bottom: After irrigation, orchards need tilling to break up the ground and keep down the weeds. It was a much harder job (though definitely a quieter one) when you had to use a team of mules or horses. This grower tending his trees (which look like they may be peaches) has to duck to keep the branches out of his face. *Courtesy of History San Jose.*

Artesian wells and rich soil—the ingredients had been there for countless years, waiting to be exploited. The sunny, dry, cloudless summers were another asset that led to the success of the orchard industry. In those days more than a century ago, the air was so clear, one settler said, you could climb up to what is now Skyline Boulevard above the valley and the redwoods of Big Basin and see all the way to Half Dome in Yosemite.

The apricot loved such a sky. And since it had arrived in California ahead of the prune, it was the first fruit to find commercial success.

In 1874, a company was formed called the Alden Fruit and Vegetable Preserving Company in San Jose. Buying from local growers, it produced fifteen tons of dried apricots that year. Writes Robert Couchman, "Its returns were so great they provided the initial incentive for development of dried apricot production in the Santa Clara Valley."

At the same time, the prune—a cousin to the apricot—was beginning to take root in California. It had not come with the Spanish but had been brought to the valley by a Frenchman, Louis Pellier, who had come to the Sierras to try his luck in the gold fields. When that was unsuccessful, he headed down into the Santa Clara Valley to start a business he knew better than mining: growing things. He bought a piece of land on the west side of San Pedro near St. James Street in San Jose to begin his planting.

He and his brother Pierre experimented with various fruits and finally founded their City Gardens Nursery at North San Pedro and Chaboya. In 1854, the brothers sent to France for cuttings, including some of the first of the Blenheim and Royal apricot trees to arrive in the valley. Among the other cuttings was a prune, the *petite d'Agen*, a fruit that had been cultivated by the French for many centuries.

Unlike the plums already growing in California, this fruit—afterward generally known as the French prune—was a variety that was perfect for drying. They are unique, says Sunsweet historian Robert Couchman, because, "They dry readily without spoiling without the pit being removed. It is this characteristic that differentiates prunes from all other plums."

By 1892, the prune still lagged behind the apricot in production, but it was catching up. The Dried Fruit Growers Union of the Santa Clara Valley reported processing 407,880 pounds of apricots and 194,336 pounds of prunes that year. In 1894, the two crops were much closer together in production: 2.8 million pounds of apricots and 2.2 million pounds of prunes. From then on, the prune would lead the apricot in the Santa Clara Valley, with the two *prunus* fruits together dominating the valley's acres of orchards.

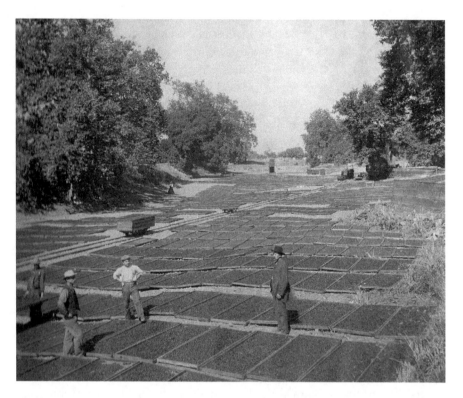

The San Jose Chamber of Commerce had this photo taken in the 1890s of the prune drying operation of a man identified as Professor Childs. We do know his orchard was located along the line of the San Jose–Los Gatos Interurban Rail Road because it was publicity for the line that led to Childs getting his picture taken for posterity. *Courtesy of History San Jose.*

Many of the advances in apricot production followed advances made by prune growers. Between 1870 and 1880, California's early farmers found a glut on eastern markets of other commercial fruit. With the help of cuttings from Pellier as well as Luther Burbank's work with early budding, growers in the Santa Clara Valley invested heavily in prunes and began harvesting with all due speed. By 1900, there were seven million prune trees in Saratoga alone, and eighty-five prune packing plants in California.

There were challenges with drying prunes, but even those were overcome fairly early on. In the 1880s, growers John Ballou and George W. Tarleton experimented with dipping their prunes in boiling water and lye before drying them. The development of that process, and the discovery that prunes dried best when they were left to ripen on the tree and fall to the ground, led to further growth in the dried prune industry. Dried fruit could be packaged and

shipped all over the United States in all seasons. California's senators lobbied for a tariff on dried fruits imported from Europe, and that helped too.

At first, most of the valley prune growers in the last decades of the nineteenth century dried their crops using evaporators. The evaporators were initially heated with wood, like a wood burning stove. Then, in 1887, the prune crop was too large and the quantity of evaporators too small to get all the prunes dried in the Santa Clara Valley.

Several of the farmers must have taken off their hats to scratch their heads and noted the cloudless sky above them and the warm temperatures around them. They considered the fact that prunes are harvested in August and September when the Santa Clara Valley has, on average, just two days during which there is measurable rain. Many years, there is no rain at all until October.

Growers decided to try sun drying the balance of their prunes. It required no fuel and minimal equipment. It had been done in ancient times by the Egyptians, the Romans, the Chinese and the Turks, but it had never been done in modern times on a large scale. It was such a success that it led to the first commercial production of sun-dried fruit in the modern world, something that continues in California to this day.

Sun drying is not a perfect system. In 1918, Northern California was hit by unseasonable rains, which devastated the crops. As Robert Couchman related, "In the Santa Clara Valley, hardest hit, the storm began on September 12 and rain fell almost daily for two weeks, winding up with a downpour in which 7 inches of rain fell in 48 hours. The storm occurred during an influenza epidemic and at a time when a great many able-bodied young men were serving in the armed forces. The labor shortage was acute. Growers who might have salvaged more of their crops had manpower been available were so shorthanded that most of their salvaging efforts were futile."

Locals described an odor of fermenting prune juice wafting from the orchards. After that, growers used a combination of sun drying *and* dehydrating machines as insurance against a similar lost season. Depending on the weather and economic conditions, one or the other form of drying predominated, and both methods are still in use today.

There was a challenge, however, with the prune's close relative: the apricot. Its lovely orange color turned black when the fruit was dried. Growers tried lots of different methods to prevent this. Then, as Stephen Payne described in his history of the county, "Henry Coe, a Santa Clara Valley farmer, found that by gassing the fruit with sulfur fumes the color of the [the apricot] was preserved and insects kept out of the fruit. Fruit treated in this manner could not only be shipped to the East Coast, but on to Europe as well."

This system was still in use in the 1950s when my parents came to the valley. My father brought home a large, castoff wooden container from a job site and turned it into our sulfur house. Then, following instructions he had acquired, he pulled out the slats from one side of the box and set it on its side. He dug a small hole in the ground, lined it with foil and placed a can of sulfur in the hole. He placed our trays of apricots on bricks that he set up in a square around the sulfur hole. Apricot trays have a rim on each end so they can be stacked without the bottom of one tray touching the top of the apricots on the tray below.

When all the trays were set up in a neat stack, Dad lit the sulfur and tipped the box over to cover up the trays. The sulfur fumes smoked the fruit and then gradually dissipated through the cracks in the slats of the crate. The apricots were left like this overnight and were ready to be set outside in the sun the next morning.

With the use of sulfur—a rediscovery since it had been known in other parts of the world throughout the centuries—it became possible to commercially dry both prunes and apricots in the California sunshine. It made economic sense for growers to diversify: if one fruit failed or the market for it was bad, a second or even a third fruit could rescue a family.

Apricots have a lower summer weather risk than prunes since apricots are harvested in July when the probability of measurable rain is close to zero. But apricot blossoms are more at risk to frost in the spring than prunes. Apricots have more pulp than prunes, and growers found—in most cases—that apricots had to be cut in half and pitted in order to dry properly. Pitting and cutting the apricots added a step—though with some practice, a good 'cot cutter could both pit and cut an apricot in one swift motion.

"The number of boxes [of apricots] cut a day depended on how fast the cutter was and the size of the fruit," Mrs. Lyle Huestis said of her family's apricot orchard in Los Altos in the early twentieth century. "Cutting alone," she said, "one might do fourteen or so [boxes of apricots a day]. Twenty-five cents a box was an average wage."

Like prunes, apricots were placed on large wooden trays. The trays were stacked in sulfur sheds much larger than the makeshift one used by my family: they had to be since some of the trays were as large as four feet by six feet in size. Then, after sulfuring, they were set outdoors in the sun for as short as a few days or as many as ten, depending on the weather and the location of the drying yard. Apricots dried today in the San Joaquin Valley (now the center of apricot production in California) will often dry in just one day in that climate's blistering temperatures.

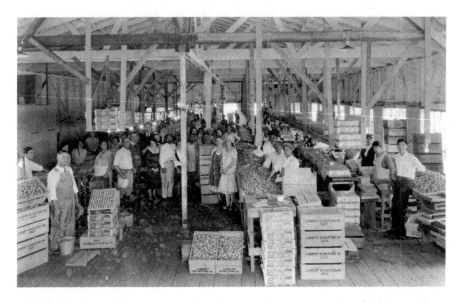

This photo of the Lambert apricot packinghouse, promoting its "Alta Glo" label, gives us a look at the multicultural nature of the apricot business in the Santa Clara Valley. It is 1931, and workers are all neatly dressed as they pack fresh apricots to ship to market. *Courtesy of the Los Altos History Museum.*

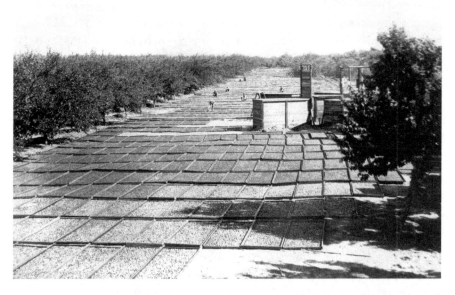

The enormous drying operation shown here is in the center of a forty-acre apricot orchard in San Jose off South Bascom Avenue. In 1935, the owners could handle forty tons of apricots each day. *Courtesy of History San Jose.*

Some of the apricot growers in the valley built small rail tracks that ran from cutting sheds to sulfur sheds to drying yards to make it easier to move the large stacks of apricot trays. You can still see some of the old rails in orchard photos of the era. Lyle Huestis described their layout and use in her unpublished memoirs, "Running the length of the [cutting] shed, through the middle of the dry yard, and out to the sulphur [*sic*] house was a small track on which flatbed cars carried trays of cut cots from shed to sulphur house…The cars held twenty or so trays. When full, they were pushed down the track into one of the two sulphur houses. [Later] the cars were rolled out on the track and moved to the dry yard."

Two local boys I know found one of the old apricot dry yard cars with the railroad wheels intact in an abandoned orchard in 1962. They put the railroad wheels on a modified go-cart and used it to take secret, motorized round trips between Los Altos and Palo Alto on the Southern Pacific's old Daylight line, which was (fortunately) no longer in use. To this day, they prefer to remain anonymous—just in case their mothers are listening from the other world.

Though simple inventions like the rail carts helped small orchard growers do their formidable jobs, they were still at the mercy of many things over which they had no control—the size of the apricot crop and the size of the apricots themselves varied depending upon the year. Even the industry itself took note of this difficulty. Here's a report in the *California Fruit News* of August 1918: "The dried fruit market is a gloriously indefinite institution in California this week…Apricots are falling down somewhat below earlier estimates as to production. This is largely owing to the small size of the fruit, which in turn resulted from the dry winter and spring. The tonnage is, therefore, less with so material a proportion of small fruit. We do not believe, however, it will turn out to be as much smaller as some are now figuring."

Imagine trying to run a business on such constantly shifting market conditions. There were also annual uncertainties in transportation costs, unscrupulous buyers, acts of nature, acts of God, the Great Depression and two world wars in the twentieth century that influenced the prices paid for produce. Growers joined cooperatives in the valley and learned again and again of the difficulties of working with middlemen.

Yvonne Jacobson tells about the year her father joined a canning cooperative and sent them his apricots. He later received the following letter, which he saved the rest of his life: "We are enclosing herewith our check no. 1729 for $15.21, which represents the total net return on your…Apricot deliveries to us. We regret that the return could not have been more but we

believe you understand the conditions which were responsible for the return not being larger."

That check represented his payment for eight *tons* of apricots.

Among the valley's early growers were members of the Mariani family who came to the valley at the turn of the twentieth century from the Island of Vis in the Adriatic. Vis—like the Island of Majorca—was the subject of a great deal of conquest over the years and, at various times, was part of the Kingdom of Venice, Napoleon's empire, Croatia and the Austro-Hungarian Empire. In all ages it was known as a fertile home of agriculture. The Marianis began with just three acres of apricot orchards in the Santa Clara Valley, and their Mariani Packing Company became the largest distributor of dried apricots in the world. Perhaps it is a coincidence, but apricots have been grown on the Island of Vis for centuries and are so beloved there that the people of Vis still celebrate an Apricot Blossom Festival.

One member of the Mariani family, Joseph Mariani, arrived in the 1930s and cultivated a small apricot and prune orchard off De Anza Boulevard in Cupertino. It bloomed across from what is today the international headquarters of Apple Inc. When the Joseph Mariani family sold their land there, they moved to Morgan Hill where one branch of the family has continued in the orchard business. Joseph's son, Andrew Mariani, operates Andy's Orchard in Morgan Hill, a specialty fruit business in which he grows at least two dozen different kinds of apricots and many other fruits. During the season, several local tech companies order his fresh apricots for their staff.

Other turn-of-the-twentieth-century orchard families include Barney Job and his wife, Juliette, who moved to the Santa Clara Valley as newlyweds from Missouri in 1890. (Barney and Juliette Job are not related to Steve *Jobs*, founder of Apple. Their last name lacks the "s" he has on his name—and that is several billion dollars worth of difference.) Mr. and Mrs. Job (without the "s") lived first off Stevens Creek Boulevard and then near Homestead Road while Barney Job worked on the farms and in the orchards of others to save the money he would need to buy his own land. Luke Pavlina and Barney Job were among the many men who spent years tending orchards in the valley as they saved to buy their own land.

Pavlina planted his apricot orchard in Sunnyvale. The Job family's first acreage was on Bryant Avenue, on the south side of Grant Road near what is now the boundary between Mountain View and Los Altos. Their orchard, planted in 1894, is remembered today in a little suburban street nearby called Apricot Lane.

As Barney Job's daughter, Lyle, remembered, "It would almost seem climate and soil were created specifically for growing of apricot and prune trees. As the trees grew and flourished, orchard after orchard sprang up till Santa Clara Valley became one of the richest fruit-producing areas in all of California."

On the Bryant Avenue property, Job and his family began grafting their first apricot seedlings. Apricot trees are susceptible to diseases that heartier cultivars are not. As a consequence, apricot trees have been grafted to peach and prune seedlings for many centuries. Growers discovered very early in California that apricots were much more likely to thrive if they were grafted, and the Job family had a part in that, as their daughter recalled, "I'm proud to say that my father and mother played a vital role in the birth of the fruit industry in Santa Clara Valley. Around the turn of the twentieth century, they cut scions which were used to graft onto small established trees, thus causing the trees to bear apricots."

When Barney Job made his final move, in 1910, to ten acres on Grant Road near the intersection of Covington and Grant, he planted most of his acreage in apricots. While the seedlings were taking root, the family planted muskmelons and watermelons between the trees as a means of cultivating temporary income. Growers learned that tomatoes, potatoes, eggplant, and okra should *not* be planted as an intercrop with apricots because those plants sometimes carry a disease called *verticilliosis*, otherwise known by the descriptive name Black Heart, which can be fatal to young seedlings. Growers today still plant intercrops between the rows of apricot seedlings to produce something to sell while the trees mature.

Grant Road was then just a long, unpaved country lane. It stretched from El Camino Real, where Whelan's Blacksmith Shop sat on the corner, all the way through the orchards to what was then the Southern Pacific Railroad line and is now the Foothill Expressway. Job told his family, after he planted his first acre of apricot trees there, that he thought Grant Road was "the prettiest road in the country."

It is easy for people who live in the developed Santa Clara Valley today to create a bucolic fantasy about these early-twentieth century orchard families. People who are now disconnected from the cycles of work on the land may imagine that having acres of orchards led to tranquil lives cultivated in the shade of the beautiful trees. Yvonne Jacobson, with her roots in the orchard business, has been careful to remind us that this is not quite true.

Instead, she recalls, life was full of "conflicts and disasters tempered by endurance, patience, frugality, and hard work." The son of one grower, John Vojvoda, put it this way: "The orchard business was tough."

Perhaps being in the midst of all those apricot trees just made the tough times a little easier to endure.

Lives in the Apricot Orchards

Cupertino had good apricots and so did Mountain View, and I still raise good Blenheims in Sunnyvale. But you can always tell the apricots from Los Altos: they are sweeter and have a richer color. It's the dirt there. Los Altos has great dirt for apricot trees.
—*Charles Olson*

The Santa Clara Valley in the early twentieth century was not a typical farming community; at least, it was unlike a farming community one might find in the Midwestern United States. For one thing, the orchards were small, and thus, for such a rural region, people were not very far from one another. In addition, the orchards were nestled between two of the oldest and largest cities in California: San Francisco and San Jose.

San Francisco was then—and still is today—one of the busiest ports in the world. Thanks to the Gold Rush, it was also one of the wealthiest. Just a short train ride from the orchards—forty minutes to an hour, depending on where you caught the train—a visitor could find San Francisco's fancy hotels, see the latest plays and shop in stores that sold the newest in fashion. People who grew things in the valley were never geographically isolated. In fact, internationally known actor John Barrymore was staying at the Saint Francis Hotel in San Francisco, touring in the play *The Dictator*, when the 1906 earthquake shook the city and knocked him out of bed.

Because of the proximity of San Francisco and San Jose, Santa Clara Valley families had access to good doctors, lively newspapers and well-

stocked bookstores. San Francisco trips were for very special days, but there were lots of places on the peninsula to shop.

Families headed to San Jose for practical purchases at department stores like Hale Brothers at First and San Carlos. They might buy shoes for their children at Herolds, 74 South First, where the most expensive pair of oxfords cost five dollars in 1932. The Orchard Supply Company (now Orchard Supply Hardware) might be another stop for growers' families on Bassett Street in San Jose. Founded as a cooperative in 1931 by thirty farmers, the co-op quickly had more than one thousand members who found they could get better deals on their supplies and equipment when they pooled their orders.

By the early twentieth century, there were also four of the best colleges in the West within a short drive of the orchards. Santa Clara University—then called Santa Clara College—was already fifty years old in 1901. Founded by the Jesuits at the end of the mission era on the lands of the old Mission Santa Clara, it awarded its first bachelor's degree in 1857.

Just a ferry ride across the bay was the University of California–Berkeley, which opened its doors in 1869. Valley students could also take the Western Pacific Line from San Jose if they were headed up to Cal. It is the oldest of California's state-funded universities and was designed as a school where students could both learn the classics and gain expertise in practical fields like agriculture and engineering. The agricultural research done there by Edward J. Wickson and his colleagues in the early part of the twentieth century led to advances in pest control and irrigation, among many other things, that could be directly implemented in valley orchards.

In 1871, the California State Normal School moved from San Francisco to downtown San Jose. It was first a school for women and turned out many teachers who served in the valley before it grew into San Jose State College and then San Jose State University.

In 1891, the Leland Stanford family founded Stanford University on the acreage of their stock farm in Palo Alto (hence its nickname, "The Farm"). Just twenty miles from San Jose and thirty-seven miles from San Francisco, it offered free tuition until the 1930s. Many growers sent their children there. Martie Job, whose family grew apricots on their Grant Road farm, graduated from Stanford in 1915 with Phi Beta Kappa honors. Her younger sister, Lyle, received her degree from San Jose State College.

Education was a key reason the William H. Smith family moved from Oregon to the unincorporated area surrounding Los Altos just before the turn of the twentieth century. They chose the region because it enabled the family to have both an orchard business and access to good schools. The land Mary

A vintage postcard of Stanford University, founded in 1891. Tuition there was free until the 1930s. *Author's collection.*

and William Smith bought was rural and surrounded by wheat fields and just a "sprinkling of homes," said their son Gilbert. There was also nearby San Antonio School, built in 1867, to get youngsters started in their educations.

Their youngest son, J. Gilbert Smith, born in 1876, became a carpenter and worked on new dormitory buildings at Stanford, often commuting to and from Palo Alto on his bicycle. His work helped his older brother Harlon and his sister Eleanor get their Stanford degrees. Thankful to the end of his life, Harlon Smith, a Santa Cruz educator, named his own son Gilbert.

By the time he was twenty-five, Gilbert Smith had aided his siblings and even spent a year at Stanford himself. But, he decided there were other opportunities that interested him.

In 1901, he bought five acres on what was then Giffin Road, a "little dirt lane" as he later called it, which had once gone all the way from El Camino Real up to La Honda when it was used as a road for redwood logging. Giffin later became San Antonio Road. "The following year, I had planted five acres in apricots and had started construction on my home," Smith told an interviewer in 1957.

The weather in the valley was so mild that Smith pitched a tent amidst the owl clover and California poppies and lived there while he built his house, which took until 1905 to complete. The square, two-story farmhouse was

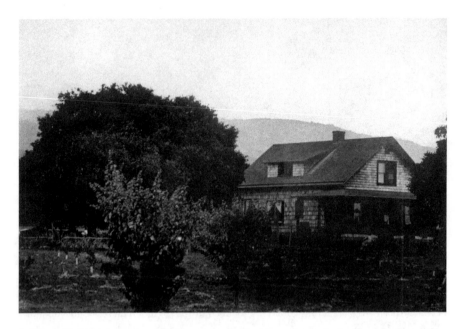

J. Gilbert Smith's house about 1905, surrounded by his newly planted apricot seedlings. The house still stands today on San Antonio Road. *Courtesy of the Los Altos History Museum.*

covered with redwood shingles and had a porch that wrapped around three sides. It had a windmill in the back and a water tower—though Smith said the windmill was knocked over in the 1906 earthquake. Along the way, Smith also acquired another five acres of land and planted that land in apricots, too. As Smith worked to nurture his orchard, he spent long hours on his house. He installed a masonry fireplace and used local redwood for the staircase and to panel some of the downstairs walls. He constructed part of the porch for use as a pantry and made another part into his office. He designed the kitchen so the boxes used for collecting fruit in the orchards would fit right into the kitchen cabinets as storage bins.

There were practical reasons Smith set up an office on the porch. Summer weather in Northern California is dry and mild, and with work going on outside, it was convenient to be able to go over the accounts in the shade of a covered porch and still be within shouting distance of the orchard. With an outside office, seasonal workers could come up on the porch, talk with him and get their assignments and their pay without tracking muddy boots into the house. "Every farmer who had seasonal workers, employees

who worked part [time]…had an outside office like that," recalled Daphne Smith, Gilbert Smith's great-niece.

The business was never without its excitement. One year, Gilbert Smith's sulfur house caught fire while he was smoking a batch of apricots. An old oak tree on the property was partly burned in the fire and bore scars of the scorching for many years afterward.

William Lair Hill and his wife, Julia, moved from Oregon to California for some of the same reasons as the Smiths. Hill was a lawyer and former editor of Portland's main newspaper, the *Oregonian*. He and his wife lived in Oakland while their daughter, Margaret Francis Hill, attended the University of California–Berkeley, from which she graduated in 1901.

In 1905, the Hills bought an apricot orchard on San Antonio Road near Smith's property and a year later bought more orchard land in Mountain View. In 1936, after Gilbert Smith's mother died, and when both Smith and Margaret Hill were well past the age of fifty, the two decided to get married. The couple lived in Smith's shingled home at 51 South San Antonio Road in Los Altos, surrounded by their apricot trees, for the rest of their lives.

By the early twentieth century, the orchards had brought Santa Clara County to the forefront of the world in fruit production. This large group of small farmers had gradually become part of an enormous business. Santa Clara Valley orchards were producing fruit that, as Robert Couchman points out, in quality and quantity exceeded the production of many nations: "Nowhere else in the history of U.S. Agriculture has there been a deciduous fruit industry that grew as rapidly, that reached great importance so quickly or was a significant economically as this industry."

There is much about the simple way these families lived that would seem foreign to residents of Silicon Valley today. At the same time, there were many things about their lives that were quite modern.

Since the 1860s, there had been public transportation of several kinds in the valley, from electric trolley cars to railroad trains. Beginning in 1908, the Southern Pacific Railway began running five steam trains a day along the western side of the valley between Los Gatos and San Francisco. Beginning in 1880, there were electric trolleys in San Jose, Santa Clara and several peninsula lines that encompassed 130 miles of track by 1929.

Goods and produce thus traveled on a regular schedule, and mail moved quickly by rail in all directions. With only fifty-seven miles between San Jose and San Francisco, and many fewer residents than there are today, the region had a transportation grid that in many ways worked much more efficiently than it does now.

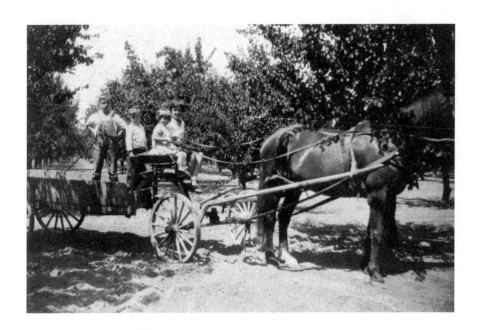

Gilbert Smith, like many valley residents a century later, was an avid cyclist and liked to ride his bike all around the region and up into the nearby hills. "In those days of no automobiles, I remember San Antonio Road as an excellent road for wagons and bike riding," Smith recounted half a century later. He even owned a bicycle built for two he could use when he found a friend or family member to ride with him.

There were lots of reliable ways families could communicate with the outside world. The first telegraph message between San Jose and San Francisco was sent in 1853. By the turn of the century, residents of the valley had this early form of instant messaging to connect them to all parts of the country. There were often two and sometimes three mail deliveries each day to valley farms. And addresses were much simpler to remember. Mail would arrive at one orchard mailbox with just this information: Vojvoda, Family Ranch, Springer Road, Los Altos.

Growers had windmills to drive their pumps. They had solar power to dry the clothes on their clotheslines and the fruit in their drying yards. Almost all of the orchard families had chickens for fresh eggs, and some kept a cow for fresh milk. Kitchen gardens provided vegetables that were fresh in the summer and canned for winter use.

Water tanks stored rainwater and well water for bath and kitchen. As the century wore on, there were cars, tractors and telephones—local telephone exchanges began to appear around 1913. William Cranston, father of U.S. senator Alan Cranston (1914–2000), connected his first telephone in Los Altos Hills in 1914, the year his son, the future senator, was born.

When engines began to replace horses, fallow pastureland that had been reserved for grazing could be planted in more fruit trees—though there was a lot less organic fertilizer for the gardens. The California Prune and Apricot Growers in San Jose began acquiring its first Mack trucks in 1918. The Job family on Grant Road got their first car in 1922—a Model T Ford they called (for reasons now lost to history) by the nickname "Nancy."

Opposite, top: A summer day in the apricot orchard for some Santa Clara Valley children. Fruit was fresh on the nearby trees, and you didn't need a driver's license to get around. *Courtesy of the Los Altos History Museum.*

Opposite, bottom: Gilbert Smith, in the hills above the Santa Clara Valley with his bicycle built for two. We don't know who was cycling with him, but it is probably the person who took this photograph. You can see he has packed a lunch and put it on the front of the bike. *Courtesy of the Los Altos History Museum.*

What was different about the lives of these orchard families was the amount of work they managed to fit into them.

"My dad would tell me the fruit didn't care if it was a weekend or the Fourth of July," Louise Pavlina Hering recalls of the long summer workdays in her family's Sunnyvale apricot orchard. "The 'cots were still going to ripen, and it was our job to get them picked in time."

Harvesting the fruit was just one part of an entire year's worth of work that included a formidable number of tasks. The trees had to be pruned in late summer and early fall—and that involved hand work done to every single tree. The prunings from the orchard were set in piles and collected by a rake-like device that was—early in the century—hauled by a horse. All the prunings were then set in the dry yard—now empty at summer's end—and disposed of by burning. Children—who can always find something fun to do when adults are working—put potatoes on the greener sticks and roasted them in the fires.

The orchard land had to be cultivated by plow or tractor several times a year. This kept down the weeds and broke up the ground so the trees would soak up more moisture.

The trees had to be sprayed to prevent diseases like brown rot, shot hole fungus and crown gall. Spraying also fought pests that loved the sweetness of apricots, including cankerworms, leaf rollers and red humped caterpillars. Some families had the equipment to spray their own trees, while some hired others to do the work. Gilbert Smith got his own spraying rig designed to fit on his tractor so he could drive through the orchard and spray the trees himself.

It was early Los Gatos resident John Bean who invented the continuous spray pump for his own orchard when he found there was no really effective spray rig available. The sprayer, patented in 1884, led to the formation of the John Bean Spray Company, originally headquartered in Los Gatos. It expanded over the years into the giant Food Machinery Corporation (FMC), which, for a time, was one of the valley's biggest companies.

Nick Vojvoda, who sprayed the trees on our property when I was a child, got into the spraying business because his father bought equipment for his own orchard. Neighbors saw Nick working and began to ask for his help. The Vojvoda family had thirteen acres of fruit trees—ten acres of apricots and three acres of cherries—on Springer Road in the Mountain-View Los Altos area. Nick later had thirty more acres of apricot trees on Valencia Drive, just off San Antonio Road, one mile south of El Camino Real.

Vojvoda recommended two sprayings each year—one main spray and one while the trees were dormant. In an interview with Nick's son, who is

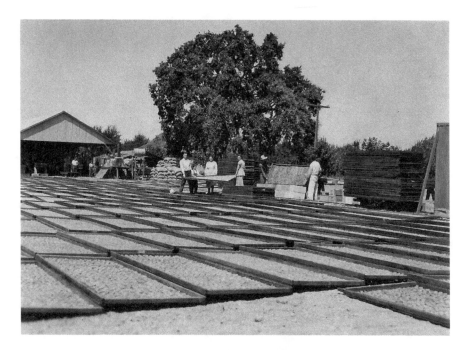

A small, family-run operation in Cupertino in about 1939. An operation this size could handle about four tons of apricots each day. *Courtesy of History San Jose.*

named John like his grandfather, this fourth-generation orchardist quickly went to his records and found the last date my father hired him to spray our suburban trees, after his father, Nick, had retired.

"It was February 1992," said John. "And I don't want to say anything bad about your father, but he called me again in May to complain that his fruit had some problems." John says he tried to explain to my father that the trees probably needed two sprays each year, and that he, Mr. Chapman, had felt that paying for a second spray was too wasteful. John and I both laughed about this. My father was seventy-three years old in 1992. He was a devoted gardener, but he had grown very loath to part with a dollar.

Nick Vovjoda had 920 customers in the valley during the peak of his business: some of his customers were growers, and some were suburban homeowners, as we were. We were always warned to stay inside when he sprayed the oily black spray on our trees. Vovjoda and his men wore black oilcloth raincoats and oilcloth hats (like the ones worn by fishermen in those days) that covered their heads and necks. When he was done spraying, he totaled up the bill and often wrote on the ticket: "Please don't forget to

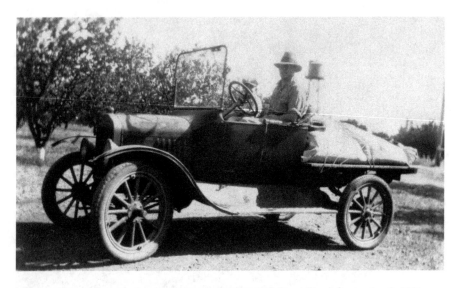

Merle and Tom Job on the Job family's apricot orchard off Grant Road, September 6, 1931. Merle was a Job son, and Tom a Job grandson. The vehicle, a truck, is clearly not the family's Model T Ford car, which was given the name "Nancy." *Courtesy of the Los Altos History Museum.*

thin out your fruit." It was a thoughtful message from a man who knew his apricot trees.

Orchard owners could not forget. If each apricot tree was not thinned by hand, it meant too much small fruit with much less sweetness. "A tree only has so much sugar," John Vojvoda points out. "So you have to thin the fruit."

Juliette Job left behind a diary from 1936 that gives us a glimpse into the labor-intensive work of apricot thinning. Recounted by her daughter Lyle Huestis, it gives us a record of the work required of orchard family members in that era. Mrs. Job was sixty-six years old in 1936, and all her children were grown and gone by then. Her husband was an invalid. In the depths of the Great Depression, money was tight. Juliette Job did the work herself and recorded it in her diary that spring:

> *April 11ᵗʰ thinned a few cots*
> *April 13ᵗʰ thinned cots using a pole*
> *April 14ᵗʰ worked awhile in the cots*
> *April 15ᵗʰ worked all day in the apricots*
> *April 16ᵗʰ Thursday—cloudy—worked four hours in morning and four in afternoon. Went over the back of the orchard to see what needs doing. About eleven rows at the back need thinning.*

April 17th thinned cots all day. Papa came out in the orchard. Finished out in front about four o'clock. Did several trees farther back.

April 18th worked west of the dry yard. Commenced east of the dry yard afternoon.

April 20th washed and went to thinning at nine-thirty. Getting along fine. Worked till five.

April 21st when misting rain cleared up I went to thinning afternoon.

April 22nd Got to work thinning at seven-thirty. Finished at quarter past eleven. Have gone over all the orchard to every tree. Some did not need thinning. Some a very little and some a whole lot. There is a good crop on almost every tree.

April 24th At ten o'clock I commenced going over the cots that are too thick. Worked till five.

April 25th Saturday. Nice day. Warm. Made cake went to town early. Left Mrs. Taylor (Job) a dozen eggs. Finished my flower bed after I got home. Afternoon went at apricots again—finished at four. Greased car. Mrs. Stevens came—she got five dozen eggs. Sent Alpha a dozen. Put out some chrysanthemums and snapdragons.

May 1st thinned apricots nearly four hours

May 5th big wind blowing. Cold

May 6th Wind still blowing—hurting the cherries and prunes.

It is daunting just to read the amount of hours this woman put in, up to and including washing, baking, gardening, raising the chickens and greasing her Ford. More important: she was not unique. The orchard families—and the thousands of orchards in the Santa Clara Valley in the first half of the twentieth century were almost entirely operated by families—worked long, hard hours. Fruit produced their income. Though seasonal help had to be employed at harvest time, there was not always enough money to pay workers to complete the other jobs.

In the spring, the entire valley was in bloom. To growers, the beauty came with a lot of worry. Too much rain on the blossoms could eliminate a year's worth of work. Too much frost could do the same. Spring was a time when growers watched the weather with concern.

Still, even locals had to marvel at how beautiful it was with thousands of orchards and millions of trees in bloom across the valley. The colors ranged from the off-white of the almond blossom, to the white and pink of the apricot, to the darker pink of the plum and the prune. The different

colors filled the valley in their turn. Barbara Collins Callison published her memories of spring in the Santa Clara valley in that era: "There were the abundant apricot, almond and cherry orchards; beautiful in the spring with pink and white blossoms that looked like snow as they fell to the ground…Mustard fields were interspersed among the trees, providing a child's play area for tunnels and forts."

The City of Saratoga, another center of *prunus* orchards, began celebrating the spring with a popular festival that attracted tourists from all over the region. As the city's own *Heritage Resources Inventory* related, "Saratoga's annual Blossom Festival, which originated in 1900, brought hundreds and then thousands of visitors to the community each year. Many admired the quality of life of the area as they spent time at the Blossom Festival, or passed through on the way to California's first state park, established in 1902 at Big Basin."

During blossom time, visitors arrived from San Francisco by train with their picnic baskets and wandered into nearby orchards to enjoy a meal *al fresco*. These had to be delightful outings, when a day could be spent in a rural valley all abloom, just a short train ride from the city. It did have a downside for the locals. Growers grumbled they could always tell the picnickers had come visiting when they found their litter beneath the trees.

When the fruit began to appear, there was another list of things to worry about. April was an especially fragile time for apricots. The green fruit was on the trees, but it still required many days to ripen. The average low temperature in San Jose in April is forty-eight degrees Fahrenheit—but the record low is two degrees below freezing. Fruit growers, like farmers everywhere, had to watch their thermometers once the fruit was out. In California orchards, there *was* actually something one could do about the weather.

In the nineteenth century, growers found they could use wood fires to help save orchard crops on especially cold nights. Experience showed an orchard needed fifty fires to the acre to raise the temperature of the surrounding air enough to save fragile fruit. This was not only dangerous, but it also wasn't always effective. If the night was very still, a fire sometimes did nothing but save the trees next to it.

After a severe frost in 1908, a Fresno farmer named J.P. Bolton, who also worked as a weather observer, invented the Bolton Smudge Pot. These burned oil and were set up along the rows of trees. Growers installed thermometers with frost alarms throughout the orchards. The smudge pots were used only if temperatures below thirty degrees Fahrenheit might be expected to last on any night for more than thirty minutes during the apricots' most vulnerable time—February, March and April.

"The practice of heating orchards or smudging is well established in some of the best apricot sections of the state," wrote Arthur Hendrickson for the University of California in 1930. A grower who could see the thermometer dropping might sleep for a few hours after supper and then awaken after midnight to work the rest of the night lighting and maintaining his smudge pots. The lowest temperatures in the valley usually occur between three in the morning and dawn.

Lyle Huestis gives us a picture of what it was like on her family's farm on a smudge pot night:

> *Each pot was about two feet long and a foot wide. It stood on legs. A stack like a stovepipe projected from the top…The smoke from the burning pots raised the temperature of the air enough so the frost did little or no damage…In the morning one had to do a good job of nose cleaning. It surely became dirty breathing the black night air…It wasn't a pleasant time for anyone, but a very necessary procedure if we were to have a crop. I've seen the time when we lost everything because the pots weren't lighted in time.*

Growers were advised to set out about one hundred smudge pots per acre to protect apricots in a rare season of a late, hard frost. Mike McKinney, whose father owned an orchard near the Coyote River in San Jose four decades ago, remembers his father's smudge pots. "What a mess," he says curling his nose. "And of course, that was when fuel was eight cents a gallon!" Smudge pots were still in use in the Santa Clara Valley as late as 1953 but were used more often in the San Joaquin Valley where temperatures tend to be colder.

My sister, who went to college at Chico State in the 1960s—in the middle of another region full of orchards—recalls local farmers coming to the school's dormitories on frosty nights, looking for college kids who wanted to earn spending money. Volunteers would spend the night working with the farmers to keep the smudge pots going. The good news is that the smudge pots were only required very, very rarely in the Santa Clara Valley.

Strict clean air regulations and the high cost of oil put an end to the era of smudge pots. Growers in California today use a combination of fans and sprinklers to protect their trees.

Each month in the orchard brought its own list of things to do. In June, when the fruit was beginning to turn a peachy color, some of the growers also irrigated their orchards. "Whenever irrigation water is available," wrote

The view looking across the Santa Clara Valley from Los Altos Hills. Larry Nelson, who operated a popular pharmacy on Main Street in Los Altos for many years, took the photo shortly after the end of World War II. *Courtesy of the Los Altos History Museum.*

Hendrickson in his 1930 advice to apricot growers, "apricot orchards are usually irrigated several times during the growing season. In some of the rolling foothill areas, however, where water is either unavailable or too costly, the trees are grown without irrigation. In the latter districts a fair crop of fruit is usually produced, but the trees do not grow so large as they do in the irrigated sections and the yields are smaller."

Most Santa Clara Valley growers did irrigate when they could afford it, and growers do so today in California's interior valleys. Still, old-timers say that 'cots grown in the foothills without irrigation will always be the sweetest, even if they have to pay for it by being a little bit smaller in size.

Pruning, cultivating, spraying, thinning, fertilizing, irrigating and fending off frost brought the apricot trees to the peak of ripeness. For growers and their families, the toughest time of the year—and the best time of the year—was harvest time. So much had to be done in such a short amount of time. The scented fruit with its peachy skin was so fragile. The warm,

sweet, juicy apricot was a summer treasure that lived for just a few weeks in the sun and then was gone for another year.

Harvest time brought a flurry of work. You could awaken early to the perfume of apricots. There were long, sunny days with twilight that extended late into the evenings. All the work throughout the year was nothing compared to harvest time in the apricot orchards.

CHAPTER 6

Apricot Summers

In the evening it was a beautiful sight to see row after row of golden orange apricots sitting in trays waiting for the sun's rays.
—*Barbara Collins Callison*

During the peak of the orchard business, there were almost twenty-four thousand individual farms and orchards in the Santa Clara Valley. The number of apricot trees in California had increased from three million in 1914 to more than seven million by 1926. It was the largest commercial concentration of apricot trees the world had ever seen.

The growers harvested 160,000 tons of apricots annually, a record still not duplicated by California's apricot business in the twenty-first century.

In fact, from the growth of the orchards in the last third of the nineteenth century through the peak of the business in the mid-twentieth century, the Santa Clara Valley was the largest fruit-producing valley in the world. Among its attractions were its small villages, each one surrounded by orchards. One historian in 1922 described Mountain View, saying, "It is noted for its mild and even climate and is at the very heart of the fruit district, being particularly known for its apricots and prunes which have reached a degree of perfection unexcelled anywhere in the country. Such is the excellence of these varieties of fruit that they are dried and sent to Europe as well as the East."

Historian Eugene Sawyer is effusive about all the peninsula towns of that era, writing about Campbell: "It has the distinction of fostering the largest drying plant in the world where twenty-five thousand trays of fruit can be

placed on the ground at one time." The "plant" was in fact a huge piece of land used as a dry lot.

The statistics on the use of the apricot crops changed from year to year, depending on the economics of supply and demand. But in 1914, 75 percent of California's dried apricots were being exported to Europe. That fact right there is a curiosity, since it represents a 180-degree turn in the apricot's travels. Until then, this fruit from the East had been moving in a steady, westerly direction in its path around the world.

On or about the third week in June, the Santa Clara Valley's apricots had to be picked and sorted, dried or canned, cooked up into jam or packed up fresh and sent to grocery stores—all during the three or four weeks each year when the fruit was ripe. For farmers, it meant their entire livelihood. As Lyle Huestis remembers, "The orange cots hung heavy on the trees. As I looked at them, they became … symbolic of our living for the coming year. The time of decision had arrived—sell to the cannery and which one—sell some and cut some. If there was a large crop, the price per ton was less; if the crop was small, the price was more."

Apricots have to be picked by hand. The fruit on each tree becomes ripe in phases with each individual apricot gaining its own size and sweetness in its own time. As a consequence, each tree must be picked three or four times to harvest each apricot at its best. The orange fruit was bright against the dark green leaves. The valley at harvest time was spectacular. From his vantage point in 1922, Eugene Sawyer observed, "To wander among the great orchards in summer, when every tree is bending beneath its weight of fruit—purple prunes, golden apricots and yellow peaches tinted with the crimson hues of wine—is to walk in a terrestrial paradise."

Because picking by hand is slow, growers tried over the years to use other methods to harvest apricots, including spreading canvas on the ground and shaking the trees. It did not produce the desired result—that is, it did not harvest the ripest fruit in the best condition. The apricot, unlike the prune, is often damaged when it falls to the ground. Apricots are still picked by hand today.

By mid-summer in Los Altos, Los Gatos, Santa Clara and Sunnyvale, Los Altos Hills, Cupertino, Mountain View and Gilroy, Morgan Hill, Saratoga, Campbell and San Jose, the dusty orchards were full of workers. Though the uses of the apricot crop varied from year to year, in 1930, Hendrickson reported for the University of California, "During the past seven years, from 60 per cent to 75 per cent of the apricot crop of the entire state was dried; from 15 per cent to 35 per cent canned; and usually less than 10 per cent shipped or consumed locally as fresh fruit."

A vintage postcard of the Santa Clara Valley before the development of the orchards. It is a stunning view of California, with its green and golden colors of an early summer. *Author's collection.*

A Spanish postcard featuring a copy of a painting by Erwin Hubert of the Island of Majorca, the birthplace of Father Junípero Serra. It looks remarkably like the coast of California. *Author's collection.*

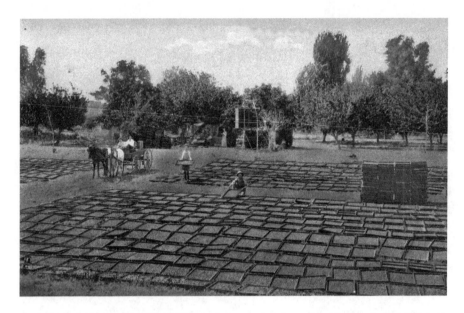

An early drying operation captured on a vintage postcard produced by Edward H. Mitchell of San Francisco. These designs were taken from black and white photos, which were then colored by hand. *Author's collection.*

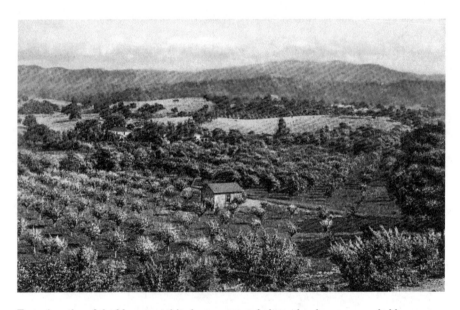

From the color of the blooms on this vintage postcard, the orchard trees are probably prunes. The "Road of a Thousand Wonders" was the promotional name for the Southern Pacific Railroad's line from Los Angeles, through San Jose to Portland, Oregon. *Author's collection.*

An orchard in the San Jose foothills on an old postcard from the Acmegraph Company of Chicago. The card was mailed on April 28, 1920, and the note on the back reads: "Just a card so you will know we are fine up here, especially me. Kind of foggy today. Something new here all the time." *Author's collection.*

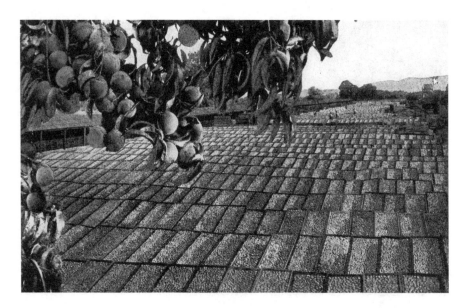

The color of the fruit in this vintage postcard scene makes it look as if it might be apricots. But from the shape of the leaves on the trees it is another *prunus* fruit being dried here—most likely peaches. *Author's collection.*

The poppies and blossoms in the Santa Clara Valley really did look like this in the spring. Until the 1940s, thousands of visitors came to the valley each year just to see the millions of trees in bloom. *Author's collection.*

Since so many tourists traveled to the valley each spring, it makes sense there would be so many vintage postcards of the scene. Postcards became popular in the years before World War I and could, for many years, be mailed across the United States with just a one-cent stamp. *Author's collection.*

The more subtle colors on this vintage card capture the look of the valley in the gentle sunlight of early springtime. The land is beginning to show a soft green from the winter rain, which will turn a sunny golden color in summer. *Author's collection.*

It is probably no wonder the visitors came down on the train in large numbers every spring from San Francisco to picnic in the orchards and scatter their litter among the trees. Postcards like this one from the San Jose Chamber of Commerce make it look like that is what a person ought to do. *Courtesy of History San Jose.*

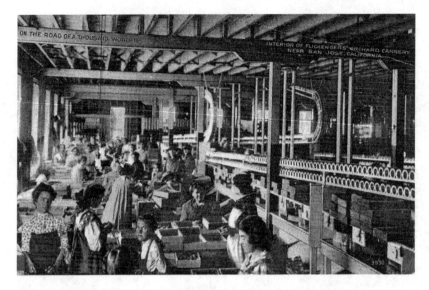

The interior of Flickengers' Orchard Cannery near San Jose is another attraction promoted along "The Road of a Thousand Wonders." The lugs of fruit shown here are flat and small. That means the workers are probably packing berries, another of the many products grown in the Santa Clara Valley. *Courtesy of History San Jose.*

"The Santa Clara Valley at Blossom Time" is the caption on this early twentieth-century vintage postcard, showing hundreds of thousands of acres of blossoming fruit trees. The view across the valley is looking east: at the top of Mount Hamilton you can see the outline of the Lick Observatory. *Author's collection.*

A somewhat sensual color lithograph of *prunus armeniaca*, the apricot, posing with a very non-apricot-looking leaf. Since the art on this vintage postcard is dated 1875, perhaps the artist hadn't seen a real California apricot tree. The leaf he painted looks much more like the leaf on a peach tree. *Author's collection*

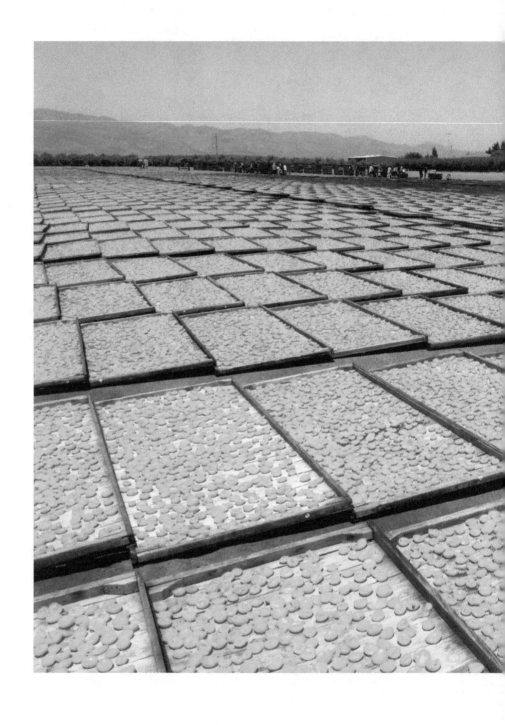

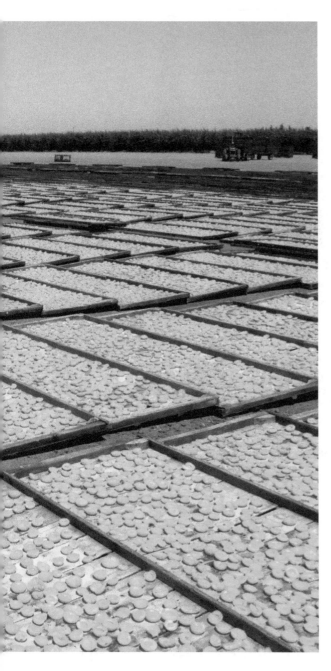

There are still some big drying operations in California, though not as many as there once were. This one belongs to George Bonacich, in Pattertson, California. The sun is so hot in the Central Valley that a tray of apricots can dry in one day. *Photo by Robin Chapman.*

Californian Gene Bays has more than three hundred acres of apricot trees. *Photo by Robin Chapman.*

Opposite: The Patterson apricot now predominates in California's commercial apricot industry. The older varieties, like the Blenheim, are called "alternate bearing" since they produce their best crops every other year. The Patterson produces a more consistent harvest. *Photo by Robin Chapman.*

Machines have never been really good at harvesting apricots, which is why they are still picked by hand. The delicate fruit is too easily damaged by machines, and each piece of fruit on the tree ripens at its own pace. Each tree is usually picked at least three times before the end of the harvest. *Photo by Robin Chapman.*

The first batch of each summer's apricot jam is always the sweetest. *Photo by Robin Chapman.*

Many who love apricots find them almost as beautiful to look at as they are to eat, but you miss the scent in a photograph. *Photo by Robin Chapman.*

The J. Gilbert Smith Apricot Orchard that surrounds the Los Altos City Hall was named by the city as a Historical Landmark in 1981. Famed architect Frank Lloyd Wright advised Los Altos to build its civic buildings here. *Photo by Robin Chapman.*

Dried apricots from one of the last orchards in Los Altos Hills. *Photo by Robin Chapman.*

Apricot trees will generally produce for about fifty years before they will need to be replaced. Growers have discovered that the trees in the Santa Clara Valley foothills, between an elevation of 400 feet and about 1,200 feet, grow more slowly, and many of the trees at that elevation will last seventy-five years or longer. *Photo by Robin Chapman.*

An apricot tree in bloom in Egypt on a vintage postcard from Great Britain. On the back it reads: "An Egyptian Spring is made beautiful by the snowy blossoms of the mish-mish (apricot) trees. The small fruit is long in ripening, hence the Arab proverb...'Tomorrow when there are Apricots.'" The saying is an older version of: "Don't hold your breath!" *Author's collection.*

The Santa Clara Valley is protected from the Pacific Ocean by the Coast Range, and its weather is moderated by San Francisco Bay. The microclimate of the valley, with its long days of sunshine and its mild winters, turned out to be ideal for production of the apricot. *Author's collection.*

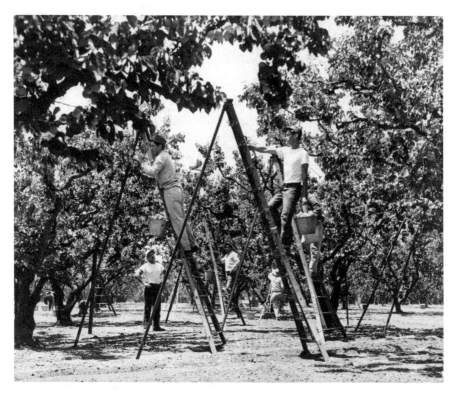

Nick Vojvoda, hands on his hips at left, with workers on his thirty-acre apricot orchard in 1950. The orchard was on Valencia near El Camino Real, in Los Altos. Nick Vojvoda was a third-generation grower in the Santa Clara Valley. *Courtesy of the Los Altos History Musuem.*

Fruit that was going to be shipped to the East was picked first when it was a good size and just beginning to turn yellow. Apricots will continue to change color after they are picked, but they will not gain any further sweetness—they will not get any more "sugar from the tree," as growers put it. Still, a firm apricot travels better than a soft one, so sweetness was sacrificed for appearance and durability in the apricots that were to be shipped as fresh fruit.

Fruit for the canneries was picked next, when it was still firm but when the apricot was turning to yellow with a rosy spot at its center. This was probably the fruit my sister remembers being picked when it was still slightly green. After they were allowed to turn a peachy color in the warehouse, apricots that were canned and turned into jam could be given added sugar to compensate for the sweetness lost to early picking.

Apricots for drying—the sweetest fruit of all—were picked when they were at the peak of their ripeness. Through the valley's history, many of the

apricots were cut right there in the orchards under the trees. Lyle Huestis remembers, "The trays were of wood, three by six feet long, each end resting on a sawhorse. A box of fruit was poured out on the tray. With a knife a cut was made around the apricot following Nature's line. It was opened, the pit removed [and] cut cots were place on the tray."

If apricots for drying are picked too early, they are too tart. If they are left too long on the tree, they become slushy on the trays. These 'cots turn into yummy blobs after drying that are designated by the unappetizing title of "slabs." Rarely pretty enough to sell, but much too sweet to discard, slabs were culled for the orchard families to keep and savor themselves.

Many locals whose families did not own orchards had their first work experience in the valley's apricot orchards. Barbara Collins Callison was one who wrote about these summers later in her life:

> *The fourth of July was a focal point for cots as they were usually ripe by this time. See if you can picture a four by twelve foot tray and how many cots it would take to fill it nearly. For our efforts we received fifty cents a tray and a lot of fun. The trays were set up under the trees to keep the hot summer sun off us and the cots. Flies were everywhere. Apricot juice dripped all over; hands, pants and cutting knives. We arrived at 8:00 AM on bikes, took a lunch break, and returned home about 4:00 PM. Boys picked the fruit and girls cut cots. We had occasional apricot fights [and] giggled over squishy cots or earwigs.*

Seasonal workers were essential to the harvest. Since the Santa Clara Valley had so much fruit to harvest, anyone who wanted summer work knew that this was a good place to get it. From the first cherries of May, to the apricots of mid-summer, through the prunes, almonds and apples of autumn, there were months and months of work to be done.

The vegetable and grape harvests that predominated in the Salinas Valley required large numbers of laborers to spend long hours stooping in the hot sun. The acreage there was vast and treeless, and harvests involved hard physical labor. Most of those who worked in the fields of the Salinas Valley were migrants, and many of those were immigrants.

The apricot harvest of the Santa Clara Valley was different. Apricots were picked in the cool of the orchards, mostly by men and teenage boys strong enough to haul the heavy buckets and agile enough to scurry up and down the fruit ladders. The apricot was ripe early, so farm families waiting for their own fruit to ripen often worked in the apricot orchards of their neighbors

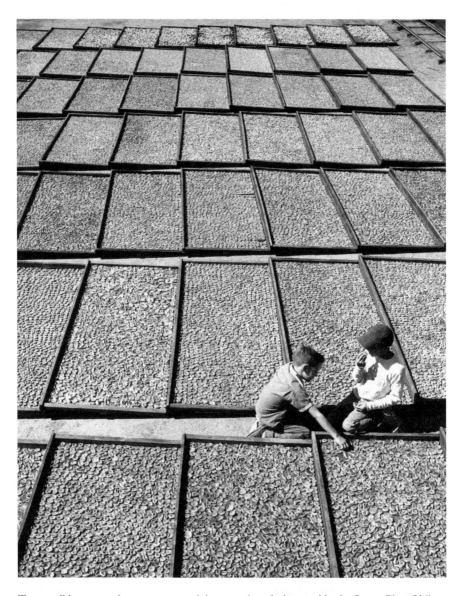

Two small boys mooch a summer snack in an apricot drying yard in the Santa Clara Valley. At the far upper right of the photo, you can see narrow gauge rail tracks. Rail carts helped move stacks of the heavy drying trays from cutting shed to sulfur shack to dry yard and back to the shed for packing. *Courtesy of the Los Altos History Museum.*

to earn extra money. Women and children—often whole families—cut 'cots together. At the Job farm, Lyle Huestis says, "Cutters, for the most part, were neighbors and friends. On occasion, migrant families camped in the orchard during fruit season. The men picked; the women cut. There were several migrant camps in the area. Here the families lived, commuting to and from their work."

Orchard workers of the Santa Clara Valley cut across many social, ethnic and economic lines. Peter Pavlina—whose father came to the valley from Yugoslavia—recalls his father hiring the same migrant families from Oklahoma who came through each summer. Yvonne Jacobson remembers her father hiring workers from San Jose's Italian American, Chinese American and Japanese American communities, some of whom had acreage of their own. The workers included townies like Barbara Collins Callison and teenagers from nearby farms who needed money for school. Just as there are today, there were always workers from Mexico. Remembered Huestis:

> When [the tray] was filled, the cutter called, "tray," or "tabla"...Two shed men came and each man lifted one end of the tray carrying it over to the flatbed car. A new tray was brought and the process began again...When fruit was needed, the cutter called "fruit," or "fruta." Around her neck the cutter wore a ticket...With each box of fruit, a number was punched. At the end of the season, a cutter's wages were paid, based on the price per box cut times the number of boxes cut as indicated by the tickets.

In 1942, just after America entered World War II, valley farmers feared there would not be enough workers for the harvest with so many Americans in uniform. According to Robert Couchman, the California Prune and Apricot Growers were among the many agricultural groups who lobbied for—and got—a guest worker program. "They took their fears to [California] Governor Culbert L. Olson and he telegraphed the War Manpower Commission stating that importation of Mexican National farm workers was vital to California agriculture. In August [1942], the Federal Employment Service put into effect an emergency program to bring in Mexican farm workers."

The program was extended many times but was finally discontinued December 31, 1965.

There were twenty thousand seasonal jobs in Santa Clara Valley canneries, too. Beginning in the 1930s, unions worked to organize them. Though early attempts failed, by 1938, most of the cannery workers in California

were unionized under the umbrella of the American Federation of Labor. Summer cannery jobs in the valley paid well after that, and there was stiff competition for them. That noon whistle I heard in my childhood was a reminder that the cannery workers all got a negotiated break for lunch.

Profit margins were narrow in the orchards, and there were almost no big corporate farms in the valley for unions to target for organization. As a consequence, unionization never reached the valley's informal system of hiring seasonal orchard workers. By the time Cesar Chavez organized his United Farm Workers of California in the 1960s, the majority of the commercial orchards were no longer operating in the Santa Clara Valley.

Growers had the independence then to look for affordable and willing workers wherever they could. Several of my classmates from Los Altos High School recalled farmers seeking summer workers at Santa Rita Elementary School in the 1950s. Santa Rita, on Los Altos Avenue, was surrounded by apricot orchards in those days, and at least three of my friends remembered permission slips being distributed in the classroom, near the end of the term, when they were in the fourth or fifth grade.

This is so unusual today that all who recounted this doubted their memories. But a little research suggests they likely remembered correctly. The Fair Labor Standards Act, approved by Congress in 1938 and confirmed by the U.S. Supreme Court in 1941, did limit child labor to those over sixteen. But there were very specific exemptions for agriculture, noted by Kerschner in his study of child labor laws, some of which remain in effect today:

> *Under federal law…children aged 12 or 13 may be employed outside of school hours in nonhazardous jobs but only on the farm on which their parent works or with the written consent of a parent. Children under 12 may be employed* [on farms] *with written parental consent… Children aged 10 or 11 may be employed to hand-harvest short-season crops outside of school hours under special waivers granted by the U.S. Department of Labor.*

Regulations approved in California put controls on the hours that minors could work in agriculture and made farmers liable if minors did any kind of hazardous farm work or worked during school hours.

When my sister Kimberly was twelve years old, she and her friend Gene Chalupa (now Venell) cut apricots on a ranch belonging to Frederick and Nancy Adams in the hills across from Stanford University. My sister remembers there was some concern from Tom Adams, the family's college-

age son who ran the operation, that she might be too young to do the work. She persevered and came home with a paycheck at the end of two weeks' work that bought her some fashionable new clothes for school. I was very envious of her profitable adventure.

Lyle Huestis remembered, "A lot of chatter accompanied cot cutting." But this wasn't always true. My sister's friend Gene found that her summer cutting apricots was a big disappointment in the chatting department. "I was fired for *talking* too much and distracting the other workers," she remembered with a lot of laughter half a century later. "How could that be? They weren't paying us by the *hour*. They were paying us by the *tray!*"

My high school classmate, Mike Hatfield worked picking apricots during the summer between his eighth grade year at Covington School and his freshman year at Los Altos High School. "I worked at Sammy's apricot orchard in 1963," he told me. "It was located just off El Monte very close to what is now the Interstate-280 interchange. We worked right alongside migrant pickers and got paid fifty cents per bucket, and we thought we were making big money."

Hatfield found the orchard chatter to be both entertaining and enlightening, though his father begged to differ. "I remember learning some new Italian profanity, which my father, Adrian, wisely explained was perfectly acceptable on the job site, but please don't bring it home," he says. "Of course, those orchards are now just a part of our history and are covered with very expensive homes."

Families in the twenty-first century concerned about all this child labor may be encouraged by the memory of Daphne Smith, the great-niece of Gilbert Smith, who sometimes worked for her great-uncle when she was a child in his orchard on San Antonio Road. In a 1994 interview, she said children did none of the heavy lifting: "Kids didn't do the picking," Daphne Smith told an interviewer from the Los Altos History Museum. "That's skilled work, and it's heavy work. A lug of 'cots is forty pounds, so that's not kids' work."

Many of the young people who worked during the apricot harvest later looked back fondly on the experience, though that isn't true of all of them. The children of farmers were expected to work, as Louise Pavlina Hering recalls. When she and her sister were in high school, she admits that they were not always happy about it. Still, almost all of the orchard kids who cut 'cots for their parents were treated and paid just like the other workers. Yvonne Jacobson says she actually looked forward to it. "I can remember beginning the apricot-cutting season full of anticipation because I was going to earn money with all the other children…The job of cutting 'cots fell to

One of the Leonard orchards in Cupertino about 1939. Freshly picked apricots have been loaded onto the trucks, which will take the fruit to the dry yard. The growers used Motel T Ford trucks for decades after they were introduced because they were small enough for use in the orchards and were easy to keep running. *Courtesy of History San Jose.*

children and families. The tedium slowed us down, and it wasn't difficult to begin trouble by throwing a mushy apricot at someone across the open shed. But we worked, and we managed to turn some of it into play as well."

It was never a simple process for so many small growers to dispense with the largest apricot harvest in the world without some form of organization among them. Growers who cultivated a variety of orchard sizes and crops and who encompassed a range of backgrounds and income levels tried many different ways to make this work.

Growers formed cooperatives and associations—the Campbell Fruit Growers Union, the Santa Clara County Fruit Exchange, the West Side Fruit Growers Association, the Women's Fruit Preserving Association and the California Prune and Apricot Growers among them. Some of the growers tried to do their own canning, and some of the canneries tried running their own orchards, with both sides discovering how complicated it was to work both ends of the business.

Eastern firms bought up fruit and supplied labels to fill orders under their own brands, just as large grocery chains do today. A number of packinghouses and canneries in the valley joined together in 1916 to form the California Packing Corporation, one of the largest organizations of its kind in California.

All of these organizations met with varying degrees of success, since they relied on a singular amount of cooperation among orchardists who were used to working on their own. The growers were an independent lot, as one famously put it in *The Sunsweet Story*: "You can get one third of the growers together in an organization; these can get another third to join; but no power outside the Almightly can draw the other one-third in."

Perhaps that is why many of the attempts at creating fruit cooperatives were born, blossomed and died, frequently ending in acrimony, recrimination, fistfights, strikes, fruit dumping and lawsuits. In 1939, growers who had contracted with one cannery in the valley protested its low prices by dumping truckloads of apricots—some of them belonging to growers who did not want this done—on the ground in the cannery yard. At issue was an offer of $30.00 a ton to growers who had set their price at $42.50.

One of the most successful and enduring of the organizations was the California Prune and Apricot Growers, which began marketing its fruit under the Sunsweet label in 1917. Though it thrives to this day and is best known now for its prunes, even this successful cooperative faced many early problems.

At first, growers who signed up one year would drop out the next, only to sign up again the third year when they heard there were better prices to be found. Some tried keeping back parts of their crops to see if they could make better deals on the side—a big no-no in a fruit association. As Sunsweet's historian, Robert Couchman, wrote on its fiftieth anniversary:

> As parents whose children have attained maturity look back on their family rearing trials and difficulties, they often wonder how they managed to surmount them. One gets the same feeling about Sunsweet as one retraces its tortuous and hazardous course and reviews its mistakes and setbacks, its often inept leadership and wavering grower support. One is tempted to conclude that here is a case in which a good idea survived in spite of the most unpropitious conditions.

In its first year, 1917, the California Prune and Apricot Growers established its offices near the intersection of San Antonio and Market Streets in San Jose and began its work of marketing fruit at a better price

Honey Dew Orchards in Cupertino, about 1940. If you look beyond the cutters you can see that the shed has been set up right among the trees. The apricot cutters cover a wide age range, including the little boy who can barely reach above the table and the adolescent girl with her back to us who, with great insouciance, has found just the right fruit box to stand on. *Courtesy of History San Jose.*

than individual growers could get working alone (they hoped). That season, Sunsweet handled $15 million worth of prunes and apricots—105 million pounds of prunes and 13 million pounds of apricots—47 percent of the total California crop of prunes and apricots that year.

Growers like the Olsons of Sunnyvale eventually contracted with Sunsweet, as did Barney and Juliette Job on Grant Road. But the Job family, at least, also sold their crop as independents to the canneries of the Hunt Brothers Fruit Packing Company in Los Gatos or to Libby, McNeil & Libby in Sunnyvale. The Hunt brothers founded their operation in 1888 in Sebastopol, California, specifically to preserve and sell California produce. By the beginning of World War II, Hunt was shipping one hundred million cans of its products each year.

There were many outlets for produce then—more than thirty canneries in the valley during the first half of the twentieth century. This complicated the equation for independent growers who did not join associations. In her 1936 diary, Juliette Job mentions getting bids from a

number of buyers that summer. And still, as her daughter Lyle pointed out, the payout seems very small:

> *June 16 Mr Popovich came to look at the cots. Sent two small boxes down to the fruit stand. Got $1.05.*
>
> *June 17 two other men came to see the cots.*
>
> *June 20 Picked three boxes of fruit for the fruit stand. Then picked from the ground and Lyle and I cut out three trays to dry for ourselves.*
>
> *June 23 picked cots to can. Only got part done. Afternoon I went to see Mr. Dale about the fruit. He came at night and made contract $700 for the trees. He wants the trays [too]. Five cents each and clean them.*
>
> *June 24 Picked apricots to can. Cooked a kettleful to run through the sieve. Papa had a bad night. James Dale commenced picking.*

It was a very different market, points out Bill Ferriera, the president of the Apricot Producers of California in the twenty-first century, which now has its headquarters over Pacheco Pass from the Santa Clara Valley, in Turlock, California. As he told me in an interview, "Back then, people could sell to independent packing companies, grocery stores, fruit stands, wholesalers in San Jose or San Francisco or even to commodities speculators who came out from the East. Growers could dry their own fruit and sell it as they chose. Today there are just three or four markets in the world that we sell to. It is all very consolidated today."

Early on, there were hundreds of packing companies and drying yards spread out around the valley so they could be close to the orchards, since, before the advent of the truck, loaded wagons were cumbersome on unpaved roads. The wagons, pulled by teams of horses, lumbered along, arrived in a cloud of dust at the packinghouses and drove right onto a scale, where the wagonload was weighed both before and after the fruit was unloaded. When trucks began to predominate in the 1920s, at first the newfangled inventions just pulled the old wagons, as if the trucks' engines had simply supplanted the teams of horses.

As systems became more automated and farmers could move more fruit at a better pace in trucks and refrigerated rail cars, packinghouses consolidated and there were fewer of them. With the successful unification of many of the apricot growers into associations, and the consolidation of many canneries, the wild speculation in the fruit business grew tamer.

One thing that did not change in the valley—until the farms themselves were lost to urban growth—small, family-owned orchards always predominated.

My sister, Kimberly, holding up two especially large apricots we harvested in the summer of 1956. Our father didn't irrigate our trees, but one of them got some extra water and produced this large fruit. As is often the case, this larger fruit wasn't quite as sweet as the rest of our crop. *Chapman family collection.*

Yvonne Jacobson cites this as a unique example of the yeoman farm tradition in America: an egalitarian niche that flourished in the microcosm of the Santa Clara Valley.

It was a business that might only have worked the way it did in that particular era, when families expected to strive together with very few luxuries and did not count on a great deal of leisure. It grew in a stunningly beautiful location that brought owners exhilarating highs and painful lows. Lyle Huestis's father died during the apricot harvest of 1936, but as her mother notes in her diary, the work had to continue:

*July 4 Saturday—sunny day and quite warm. Not a very good
"Fourth" for us. The children all here and we are doing what
we can to make Papa comfortable. Frances Mercer [a nurse]
came at five and gave him a quieting injection. Men picking
cots today.*

*July 5 Sunday. Warm today. All of us at home. Doing what we can
for Papa. Frances Mercer came up afternoon to help. Papa
passed away at five o'clock.*

July 10 James Dale finished our apricots at noon.

It is difficult today to imagine this life. In aggregate, it was a huge, modern
agricultural business. Yet each plot was independently owned and operated.
Perhaps only these remarkable people could have made it work. Few got
rich—but almost none went hungry. Yvonne Jacobson watched her father
wear himself out working in the family orchard. "While there were men
hired to...work, much of it was done by the farmer himself. There was
hardly a farmer who worked the long hours, the punishing routine from
day to day, from month to month, from year to year, who did not grow old
looking something like the crooked branches of the trees."

For those who endured, there were riches ahead—not from the apricots,
but from the land. In the meantime, these families fed others through their
harvest and rejoiced in the unique benefits bestowed on those who lived and
worked beneath the trees. Lyle Huestis had memories of the sweetness of their
lives: "The best apricots went to the cannery. [But] never a summer went by
that we did not cut at least some culls, imperfect and small cots [for ourselves].
There was many a busman's holiday, when after a day's work cutting cots we
made apricot sherbet for supper, or canned cots, or made jam."

CHAPTER 7

The Influential Apricot

As a young boy, I used to pick apricots from our trees in Los Altos Hills and go with my father to his job at Stanford Research Institute and sell them. Lunchtime at SRI during the apricot season was very profitable for me.
—*Alden "Stretch" Andersen*

If Silicon Valley ever invents a time machine to the specifications set out by the writer H.G. Wells, it would be fascinating to set the dial for the top of Mount Hamilton in the spring of 1950. The time traveler would be treated to a spectacular view. Six hundred thousand of the valley's acres, or almost two-thirds of the land, was in agriculture then. From the top of the dome of the Lick Observatory—why not, since we're teetering on the brink of physics anyway?—the traveler would see millions of fruit trees blooming in the valley below.

But he would also see the beginnings of the development that would transform the valley from a place known for its agriculture to the world's most famous valley of new ideas. Housing developments and hospitals were starting to sprout in the orchards. Condominiums, townhouses, malls, technology company headquarters, churches, schools and highways would follow.

You could see it happening in the 1950s, even if you traveled to the valley by more conventional means than a time machine. Robert Hochmuth, a minister with the Wisconsin Evangelical Lutheran Synod, arrived in the valley in 1959 to answer a call to serve a new congregation that did not yet have a sanctuary. The synod was small, and so was the budget for a new church.

Someone told Pastor Hochmuth he should talk with the Marianis, one of the most successful orchard families in the valley. The family knew a lot about Santa Clara Valley land.

Hochmuth says he was somewhat surprised to find the Mariani office in a Quonset hut in the middle of an orchard at the corner of Homestead and the Sunnyvale–Saratoga Road. It was Hochmuth's first lesson in the valley's unpretentious way of doing business. His second lesson came from the Mariani representative he met with that day. Though he does not remember the man's name, he has never forgotten his advice.

"Young man," said the representative in the Mariani office, an opening the retired minister loved recounting half a century later when the he was eighty-eight years old. "Cherries are making a profit. Apricots are breaking even. Prunes are losing money. What you need for your church is to find yourself a prune orchard."

Robert Hochmuth and his congregation took this advice and found a willing orchard owner on Pomeroy Avenue in Santa Clara. In order for the deal to go through, the orchard had to be condemned and all of its prune trees removed. Peace Lutheran Church still stands on that same land today and, there isn't an orchard for miles around.

During the boom in the valley that began after World War II and has never really stopped, the business of growing fruit faced this new challenge: people. Agriculture became an international enterprise after World War II and the value of land for development in many places in coastal California gradually exceeded its value for cultivation.

There would continue to be record-setting harvests of apricots in California for a time. All of the apricots in the United States would continue to come from California for several more decades. But things were definitely changing. In 1960, for the first time in ninety years, there were more apricots grown in California *outside* the Santa Clara Valley than inside it. About 40 percent of the state's apricots that year came from the Sacramento region; 37 percent from the Santa Clara Valley; and 21 percent from Napa/Sonoma, with the balance coming from small orchards around the state.

The orchards of the valley had survived two of their most difficult decades by then. The years of the Great Depression in the 1930s and World War II in the 1940s brought serious economic challenges to growers. Those two definitive eras also brought the federal government into the valley's orchards for the first time.

During the Depression, government agencies provided money and programs designed to help during the emergency in which unemployment

surged above 20 percent. The programs brought benefits, but they also brought regulations and red tape to a business that had been largely without these things for most of its history. Independent growers, who had proved challenging to organize at the best of times, did not find this new partnership an easy one. The California Prune and Apricot Growers, which, notes Couchman, had lobbied Washington for the assistance, found it problematic: "It is a record of monotony and fickleness, of regularly discarded half-tried measures for some new, similarly poorly prepared and shortlived program. Perhaps what happened is accounted for partly by the depression nurtured anxieties of growers and packers and partly by the inexperience of officials who were eager to extend the power of government far deeper into agriculture than it had ever been."

Growers in the Santa Clara Valley were lucky in some ways during the Great Depression. Most of them owned small operations and had worked and saved so they could pay cash for their land. Thus, not too many were burdened with debt. With chickens in the henhouse, homegrown fruit and vegetables in the larder and neighbors to barter with, most were able to get by. It wasn't true for everyone. The ten acres now planted in apricots at Sunnyvale's Orchard Heritage Park was part of a much larger orchard lost by its owners during the Depression and sold off in parcels on the steps of the nearby courthouse. Orchard owners were used to facing tough times. "I asked Otis Forge [a grower] specifically about the Great Depression," Yvonne Jacobson wrote in her book *Passing Farms, Enduring Values: California's Santa Clara County.* "His comment was, 'What do you mean? It was all depression!'"

During the 1920s, growers in the Santa Clara Valley had increased their production of dried fruits to meet the big demand for them in Germany. Many of these orders were enabled by large American loans designed to help Germany rebuild after World War I. In 1933, with Adolph Hitler's ascendance, Germany curtailed its imports of California fruit and began buying what it needed from Eastern Europe. About 16 percent of California's dried fruit market disappeared abruptly.

It came at a time when the Depression had already reduced both demand and prices for Santa Clara Valley's chief products. According to *The Sunsweet Story*:

> *There was no other market then capable of absorbing California's excess production. The huge supplies available depressed prices far below what they otherwise might have been, even under depression conditions. Growers who had expanded their orchards at considerable cost of money and effort were reluctant to cut their production back to depression market needs. So*

this was a period in which the production of prunes, dried apricots and dried peaches continued at high levels; prices continued to be low; and growers sought to produce the largest crops possible to offset the low prices.

It isn't always a comfort, during times of trouble, to learn that things could be a lot worse. But valley growers saw evidence of this as the Depression deepened. Whole families of refugees from the Dust Bowl came through the valley looking for work. And those were the families who were able to stay together. The Depression also produced men who took to the rails and roads, alone, in search of work. Lyle Huestis was going to college in Berkeley in 1936 where she got a letter from her father with news of the family orchard and a report of her father's encounter with one forgotten man. He wrote, "The apricots are beginning to bloom out, but it will be some time before they are out in full. We shall let you know so you can get down to see them. There seems to be a good prospect for a heavy bloom. We have a nice old tramp (hobo) in the barn who came last night and asked permission to sleep in the barn as it looked stormy."

Huestis added, "While I lived at home, I remember several times when a tramp asked to sleep in the barn. Mama saw to it that none went away hungry. Often the visitor performed some small chore by way of 'thank you.'"

During the Depression, for the first time in its history, the federal government began buying up large quantities of the valley's prune and apricot crops to distribute to the nation's hungry. The program kept growers from plowing under unsold fruit, and the wealth on their trees helped feed those in need.

The economics of the business began to improve by the end of the decade as war began in Europe. Though America remained out of the war until December 7, 1941, President Franklin Roosevelt started earlier than that involving California's orchards in the fight against Nazi Germany. In the spring of 1941, Congress approved Roosevelt's wily Lend-Lease plan, which allowed the United States to stay neutral and yet supply Great Britain with essentials, by "lending" them. Those who have long believed that Lend-Lease was just about a few old ships may be surprised to learn it was also about apricots.

The California Prune and Apricot Growers report that almost as quickly as the bill was signed, Lend-Lease buyers began competing with other speculators for California's 1941 apricot crop. Growers who thought they might have to strike to get prices above the $37.00 per ton they had been surviving on during the Depression found canneries willing to pay $57.50 a ton. The talk of strikes vanished.

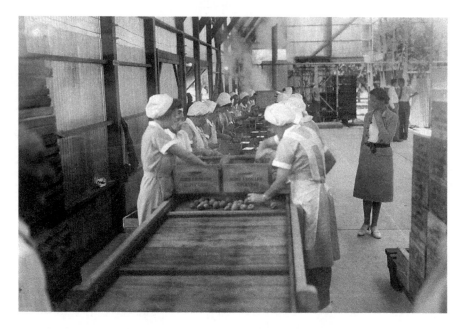

A production line at a Cupertino apricot packing plant during World War II. The perplexed woman looking on is a technician from the Food Science Department at the University of California. The two men conferring in the distance are a food technologist and an army supply officer who were working to develop a concentrated product for overseas shipment. *Courtesy of History San Jose.*

When the Japanese bombed Pearl Harbor on December 7, 1941, and the United States entered World War II, apricots had a new job to do. Though it is difficult for people to imagine today, *all* the industries of America were put onto a war footing. Prices for everything from gasoline to groceries were subject to ceilings, floors and every other kind of control, including rationing. The military got top priority "for the duration," as Americans called the war.

Tin, iron, aluminum, copper, brass and steel—every kind of metal and alloy—went into guns, tanks, planes, ships, ammunition, armor plating, mess kits, engines, portable cook stoves and helmets. Santa Clara Valley canneries found it difficult to get enough cans for canning fruit. As a consequence, just about every apricot that came off a Santa Clara Valley tree during World War II was dried. It was hard to find enough workers to get even that job done, but everybody in the valley who was not in uniform—young and old alike—pitched in. Legal workers were allowed in from Mexico for the harvest.

Fruit drying could be done in the orchards and was thus less labor and transportation intensive than canning. Dried fruit shipped with ease and was a good way to get vitamins to soldiers. Sixteen million Americans served in uniform during World War II, and all of them had to be fed. According to Couchman:

> *The declaration of war on December 7, 1941, stimulated, in the month that followed, the heaviest buying of dried fruits the industry had ever experienced. The California Fruit News reported on January 10 [1942] that "The dried fruit industry in California starts the new year with the closest cleaned-up condition of supplies that has ever existed since the industry was a sizable business. There are practically no apricots, figs, peaches, apples, or pears. Raisins and prunes are thought to be barely enough supply to take care of domestic requirements until next summer, and even this provided that the government does not buy or requisition further tonnages than now expected."*

From March 15, 1941, though May 31, 1943, the U.S. government bought 38,052,825 pounds of dried apricots for the U.S. military and its allies around the world. In the summer of 1943, the U.S. government bought up the entire crop of California's dried apricots, and growers got double the previous year's price. In 1944 and again in 1945, all the apricots produced in California were reserved for the war effort. At the end of each year, if there were any dried 'cots that had not been shipped to the troops, the government released the supply to buyers. Civilians, who had saved their ration coupons for just such an opportunity, quickly cleared the shelves.

My father's letters from the Battle of Okinawa make no mention of apricots, but he does write often about food and how much he misses fresh fruit. To quote one of his letters home from the tiny island of Ie Shima in June 1945:

> *We are still eating "C", "K" and "10 in 1" rations, but we eat them in the mess hall. Our cooks do a swell job of supplementing these rations with baked rolls, cake and pies... These rations have improved a great deal since the first of the war and they are quite good and nourishing, and there is really more than we can eat. I doubt that I have lost any weight at all. Of course there are lots of things we miss. I like as you know all kinds of fresh fruits and vegetables and we don't have any of these things at all.*

The apricot trees in the Chapman backyard, Los Altos, 1957. The landscaping has matured quite a bit since the house was completed in 1949. *Chapman family collection.*

It certainly explains why America's returning veterans who moved to California after World War II cherished those fruit trees in their gardens. Growers, meanwhile, had faced strict government controls on their profits during the war and had a new set of problems afterward. Government contracts disappeared, costs increased, unions organized and land values and taxes doubled and tripled.

Thousands of veterans, like my father, came to California when the war was over. The G.I. Bill created the opportunity for many of them to go college, and the San Francisco Bay Area had some of the best colleges in country. The Santa Clara Valley was then a stunning stretch of cultivated

orchards with two large cities on either end. With mild weather year round, pleasant breezes off the ocean and the Bay and few of the insects that plagued the South and Midwest, it was a revelation to many veterans. My parents were among the thousands who saw the valley and settled into it for the rest of their lives.

The defense industries that kept civilians working during the war continued to produce jobs during the Cold War. The Bean Spray Pump Company of Los Gatos had developed into the huge Food Machinery Corporation (FMC) by building military landing craft at its plant in the 1940s. It continued to get defense contracts in the postwar period. Ames Aeronautical Research Center, funded by federal dollars, sprouted at Moffett Field and then became part of NASA during the boom years of space exploration. The navy maintained a naval air station at Moffett to track Russian submarines.

Because these other defense industries were now in the region, IBM and Lockheed moved to the valley. "When you saw the bumper to bumper traffic going to IBM, you knew the distribution of the land was changing," said Lou Barbaccia Jr., in an interview published in the *San Jose Business Journal's* "From Farms to Fabs." His family owned sixty acres of orchards on Cottle Road in San Jose when IBM opened its offices nearby in the 1950s. Selling out, he later said, was not such a bad thing after "the years of struggle—how tough it was to live year by year."

The evidence of what happened is clear from the census data. In 1940, the county's population stood at 174,000. By 1950, the population of Santa Clara County had risen to 290,000. By 1960, it was 642,000. By 1970, it had passed 1 million. In 1998, only about 200,000 of the county's acreage remained in agriculture, and 120,000 acres of that was rangeland. By the turn of the twenty-first century, there were 1.7 million people living in Santa Clara County. The space those residents needed for living and shopping and driving and parking left little room for orchards.

It wasn't just the population and the acreage that were changing. People were changing too. After World War II, Americans began to look at work differently. Their expectations for themselves and their families were not like those of their fathers and grandfathers. Jacobson wrote:

> A bit of local humor had it that Louis Pellier, the man who, it will be remembered, introduced the French prune, was the best educator in the Santa Clara Valley. The reason: children picking prunes on their hands and knees had such a good taste of physical labor that they determined to go to college and avoid doing such menial work for life. This story illustrates the

El Camino Real in Mountain View, 1947. The new W.&J. Sloane Furniture store certainly stuck out, surrounded as it was by all those orchards. Locals may be surprised to see El Camino Real with so few cars on it in the middle of the day. *Courtesy of the Los Altos History Museum.*

shifting attitude toward manual labor. At one time it was an honest way to earn money; Americans and immigrants alike were happy to take it. Today however, it is looked down upon. It offers less money and fewer benefits than other kinds of work. As a result, we have come to rely more on laborers from Mexico and mechanical devices.

Barbara Callison discovered this new normal when she tried to share with her children her own experiences cutting apricots one summer. "In the 1960s I introduced our three oldest children to cutting cots. There were still a few operating orchards in Los Altos and I think they went out on Fremont Avenue...to experience their first apricot cutting season. For years I had raved about what fun it was. You can imagine how thrilled they were. I think they lasted all of one week."

By 1964, the number of valley farms had dropped almost 90 percent. Where there had once been 23,000 farms, there were now 2,631. In the state, there were still 35,000 acres of apricot trees, but the majority of them were no longer in Santa Clara County. Gradually, there were also fewer acres of apricot trees statewide, as less expensive Turkish dried apricots entered the

Grower Gene Bays checks his apricots during the harvest near Patterson, California. Bays is a veteran grower who has served as chairman of the board of the Apricot Producers of California. *Photo by Robin Chapman.*

market. Turkey is a United States partner in NATO and has strategically located air bases on the edge of the Middle East.

John Vojvoda, a second-generation grower, sold his apricot orchard on Springer Road in 1953. His son, Nick, continued to operate a thirty-acre apricot orchard on Valencia Drive in Los Altos until he, too, sold out in

1960. Nick's son John (grandson of the *earlier* John Vojvoda) still operates the Vojvoda spraying business, and he and his wife have held on to a small family apricot orchard in Los Altos Hills. They don't keep it for commercial reasons—they just don't like the idea of missing a summer of fresh apricots.

Most of the growers did well when they sold their land, settling into a retirement made comfortable by the profit. Some used the transition to get into the development business themselves. One of Burrell Leonard's apricot orchards became Cupertino's Vallco Park. Until his death at the age of eighty-nine in 2000, Leonard became one of the valley's leading philanthropists. The Pavlinas began developing their thirty-four-acre apricot orchard when the extension of Remington Drive through to El Camino Real divided their land in 1965. The roadwork also cut into nearby apricot orchards owned by the Canerlichs, Steve Vidovich, Andrew Bandur and Ray Tikvica. The Vidovich family got into the business of real estate development too. The Pavlina apricot orchards became an apartment complex, an office building and a shopping center.

Grower Gilbert Smith of Los Altos could see in the 1950s that the future did not bode well for his business. When he married Margaret Hill in the 1930s, he married into a family of lawyers: perhaps it was their legal advice that helped him come up with his plan. Good luck, as usual, also played a part.

Los Altos incorporated as a city in 1952. In 1953, city officials began looking for a place to put a city hall. Smith's orchard just happened to be located across San Antonio Road from the town's Main Street. The people of Los Altos had incorporated in order to keep their little town unique. Toward that goal, city officials enlisted the help of one of the nation's leading architects to advise them. According to George Estill, a city council member at the time, and Joseph Salameda, the city's first building inspector, that is how Gilbert Smith met Frank Lloyd Wright one day under the apricot trees. "We were fortunate enough to have [Wright] tour the sites under consideration and give his thoughts. He decided the Smith place was the best for several reasons—the trees, the heritage of Smith's [orchard] and the fact that it was one of the earliest houses. There was also more space available than at the others. It was rather apparent this was the spot."

Smith and his wife, Margaret, did not have children to whom they could leave their land. Instead, when the negotiations were complete, Smith agreed to place a proviso in his will that would give 1.36 acres of his land, including his house, to the City of Los Altos, upon the deaths of his wife and himself, so that the house might one day be preserved as a museum. He

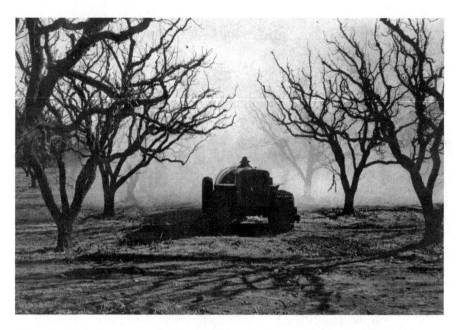

Gilbert Smith spraying the trees he loved in his apricot orchard on San Antonio Road, about 1950. Smith planted the trees just after the turn of the twentieth century and operated the orchard until his death in 1966. *Courtesy of the Los Altos History Museum.*

sold the balance of his 10.20-acre orchard to the city for what was then the substantial sum of $115,000. In return, he and his wife were granted life occupancy of the home and a life use of the orchard. City official Joseph Salameda said the Smiths were promised that the apricot trees would "only be cleared as necessary" in an agreement that also stated, in almost Biblical language: "…you shall have the fruit from the trees so long as you may desire and so long as you work the property yourself and maintain the trees…"

Smith worked the property until his death, in 1966, just a few months shy of his ninetieth birthday. His wife, Margaret, continued to live in the historic home and operate the orchard until her own death, at the age of ninety-five, in 1973. It is true that running an apricot orchard is a business. It is true that Smith proved in his deal with the city he was a very astute businessman. But anyone who says the business of apricot orchards was *just* a business would not be speaking accurately. When the city first pulled up some of his apricot trees for its new city hall, Gilbert Smith stood by with tears in his eyes.

In July 1978, five years after Margaret Hill Smith's death, the City of Los Altos was honored with Santa Clara County's Historical Heritage

Commission's Award for Excellence in Historical Preservation. "The basis for making the award," wrote chairman Gail Woolley, "is your preserving of an early residence and apricot orchard and adapting the house as a history center. The Commission was impressed with the strong support demonstrated by your city in preserving a part of our valley's heritage."

On May 12, 1981, the City of Los Altos gave the Gilbert Smith Apricot Orchard designation as a Historical Landmark. The *Los Altos Town Crier* of May 20, 1981 reported, "The landmark designation assures that no structural alteration will be made to the site without public hearings. [Historical Commission Chairman Lee Lynch] indicates that should civic center expansion be undertaken, alternative plans might be considered in order to leave the orchard intact."

Reporter Dan Honda wrote in the *San Jose Mercury News*: "Some of the trees are survivors of the original orchard planted by the property's former owner, J. Gilbert Smith, in 1901. As the old trees die off, they are replaced with new ones, assuring that there will always be at least one apricot orchard in Los Altos."

As the years have gone by and the valley has changed from rural to suburban, a few other local cities have been able to preserve heritage orchards. Charles Olson had been operating an apricot orchard on thirteen acres of surplus land owned by the City of Sunnyvale for more than three decades, when, at the beginning of the twenty-first century, residents moved to have it designated as Orchard Heritage Park. Now it will be maintained as an apricot orchard "in perpetuity," says Olson. He still cultivates the Blenheim apricot trees he planted there in 1977. The apricots are sold by the city and by his daughter, Deborah Olson, at the family's historic fruit stand, C.J. Olson's Cherries, on El Camino Real.

In 1984, the City of Saratoga established its Central Park Orchard that includes 13.9 acres of apricots and prunes. A city report notes, "As development encroached on the last remaining orchards in Saratoga, this site was chosen to represent the important early history of Saratoga and the role orchards played as the economic backbone of the town…it was preserved as an orchard as it was one of the last remaining orchards in the city of Saratoga in the 1980s."

The Saratoga Central Park Orchard now surrounds the city's library, giving it a rural look enclosed as it is by trees. Residents can walk and bike around the orchard in all seasons along Heritage Orchard Loop.

The David and Lucile Packard Foundation quietly operates a sixty-seven-acre apricot orchard in Los Altos Hills that was purchased by Hewlett-Packard founder David Packard in the 1950s. Packard used to come home from HP and go out and work in the orchard "for therapy," he told friends. During

his lifetime, he gave away most of the apricot harvest to his employees in a sort of "you-pick-it" employee benefit program. If there were any apricots left after that, he dried them and sold them at a table in front of his house, using a cigar box and the honor system. Today, neighbors still enjoy the open space of the orchard and its bounty.

The City of Mountain View has preserved what was once a prune orchard adjacent to Cuesta Park as the thirteen-acre Cuesta Park Annex. Though there have been ongoing discussions for four decades of developing the land (most recently as a flood basin), Cuesta Park Annex remains filled with wildflowers and aging fruit trees, a favorite location for neighbors to stroll and artists to set out their easels.

There are still a few privately owned commercial apricot orchards, mostly at the southern end of the Santa Clara Valley. One is operated by Andrew Mariani, a Mariani cousin, who has turned what was once his family's apricot and cherry orchard in Morgan Hill into a specialty operation. Andy's Orchard, as it is now called, attracts foodies from all over Silicon Valley for its homegrown products and for Andy's orchard tours. He can describe the individual characteristics of at least two-dozen different varieties of apricots he grows (and many more than that he has yet to cultivate), from Moongold to Hemskirt and from Blenheim to Moorpark. Chat with him and you'll hear him bemoan the day he bought a truckload of Tiltons for drying. "The Tilton," he says with dismay. "What a disappointment. No *aroma!*"

If some in the valley regret the loss of the orchards, it may be less for the sake of nostalgia than for this lost sensual connection. "We've gained a lot from these things they've invented in the valley in the last forty years," says Charles Olson. "But we've lost a lot too. There used to be eight or nine million fruit trees here. Now, in Sunnyvale, we have just eight or nine hundred."

Couchman says, "Nowhere else in the world was anything like this to be seen; neither is there anything like it to be seen now. Thousands of persons came to California year after year until the 1940s to see the breathtaking beauty of these fruitful valleys. We are greatly poorer to have lost most of it, poorer not only because so much of it is gone, but because in recent decades we have also lost some of our appreciation of great natural beauty of this kind."

For more than a century, apricots grown in the Santa Clara Valley produced many benefits for California and the world. They helped small farmers support their families with honorable work and gave their children brighter futures. During the Great Depression, apricots helped feed the hungry. During World War II, they brightened the ration kits of Allied men and women who risked their lives to make the world a better place.

When my parents died just a few months apart in late 2009 and early 2010, I found this young Blenheim apricot tree they had planted just outside our back gate. I made my first batch of jam from its bounty. *Photo by Robin Chapman.*

In the twenty-first century, apricot production shifted to California's San Joaquin Valley. The industry there raises about half the apricots once produced in the Santa Clara Valley. Nevertheless, California is still the number one apricot producer in the United States and has few commercial rivals in the world. The Central Valley's Patterson apricots have made apricot jam one of the top three jam flavors in America—

following grape and strawberry, two ubiquitous fruits that are much less expensive to grow.

Beloved by tech giants from David Packard to Steve Jobs to today's epicureans who dine on fresh apricots (in season, of course) in the lunchrooms of Google Inc., the apricot has left a lasting mark on the land that became Silicon Valley.

The apricot orchards of the valley aren't really lost. The soil and sunshine that nurtured them haven't gone anywhere. One day, they may be needed again. In the meantime, those who seek to emulate the greats of Silicon Valley might do well to eat more apricots.

CHAPTER 8

Cooking with 'Cots

It was only when I was an adult that I came to appreciate apricots and went to my grandmother, Hazel, to learn canning. I canned with her for many years until she died. Now, I can for myself and friends, trying to do it on the Fourth of July, when the apricots are at their best.
—Brian Cilker

My mother spent much of her time every summer canning and making jam. With the apricots our father dried each summer, we had our own fruit to enjoy all winter. Although I did learn a great deal by watching her over the years, my mother never shared the secrets of her jam making or her canning. It wasn't until I moved back into the family home in the Santa Clara Valley, after she and my father died, that I began to feel the loss of this.

I did find a few of her recipes. I also began collecting others from neighbors, friends and archives. Family members who are more experienced cooks than I am helped me test them. Others I tested myself to see how difficult they were for a beginner.

My first summer of jam making was especially successful and must be attributed to beginner's luck. It helped that I had an easy recipe with one practical feature: it allowed for two pauses in the process during which time the fruit was allowed to sit. This made it possible for me to work on the jam in easy stages, leaving time in between for doing other things. If it is hot in the summertime where you live, the jam recipe I used will allow you to work

on your jam in the cool of the morning and then set it aside during the hot hours and pick it up again the next morning.

A good way to tell the favorite recipes in any family is the time-honored method of picking up a cookbook or recipe file and finding the ones that are the most stained with food. I noticed that my jam recipe was covered with apricot-colored blotches by the end of July. It was a good indicator of the fun I had making my first batches of apricot jam.

APRICOT JAM—IN THREE STAGES

After I discovered my mother had no apricot jam recipe in her recipe file, I found this printed one in a stack of clipped recipes she had saved. It had no stains on it, so I'm not sure she tried it, and it was clipped too carefully for me to be able to identify its origins. I can vouch for the results.

INGREDIENTS
3 pounds of apricots (about 6 cups)
2½ cups of sugar
¼ cup fresh lemon juice

1. Cut the apricots in half and remove the pits. Cut up the fruit into small pieces. Mix the apricots, sugar and lemon juice together, by hand, in a ceramic bowl and cover them with a towel. Set this aside at room temperature for several hours—or, leave it overnight in the refrigerator. Stir occasionally to help the sugar dissolve.

2. When all the sugar has been dissolved, pour the mixture into a wide, heavy-bottomed, nonreactive pot and bring to a boil over medium heat. Reduce the heat to low and simmer for eighteen minutes, until the fruit looks translucent and is beginning to break down. Stir frequently.

3. Pour the mixture back into the bowl and let it cool. Cover it with a towel and set it aside, again, at room temperature for at least six hours or overnight in the refrigerator. When you have a few minutes, boil some water and sterilize your jam jars.

4. Over low heat, bring the jam to a simmer, stirring frequently. Cook your jam mixture for another ten to twelve minutes until the fruit has mostly broken down and juices look syrupy. Scoop a small amount of the jam onto a clean metal spoon. When you tip the spoon and let the juice run off the

You might think that making jam is difficult. But how can even a beginner go wrong with apricots and sugar and a little heat from the stove? *Photo by Robin Chapman.*

edge, the last drops will look thicker and run together when the jam is ready. Remove from the heat and ladle into clean, sterilized jars. Top each jar with a canning lid and a lid band.

Set the jars aside on a clean towel and do not touch or move them until they are completely cool. You will hear the "pop" sound as each lid seals. (Some people advise boiling the lids before using to help in the sealing.)

I have a neighbor who is a native of France and who lives on an acre that has on it the remains of one of the valley's old apricot orchards. She has lots of fruit each year to experiment with, and when she makes her jam, she sometimes adds finely minced almonds at the very end. The results are excellent.

GRANDMOM EDITH TAYLOR'S APRICOT JAM

Here is a very old Santa Clara Valley jam recipe from Carole (Mrs. Peter) Pavlina. Her Taylor grandmother—Grandmom Edith—who grew up among the apricot orchards of Mountain View at the end of the nineteenth century, handed down this recipe to her.

Cut approximately 2 quarts of apricots. Add no water. Cover tightly and cook until boiling. Stir occasionally to keep from sticking. Then, cook uncovered on low heat until 'cots are mushy and there is little juice—about 40 to 45 minutes.

Add sugar: 1 cup to each cup of fruit. You can add 1 can crushed pineapple along with the sugar if you like. Stir and cook until sugar is dissolved. If you cook the fruit too long at this point, your jam will turn brown when it cools. Fill clean pint jars to 1/8 inch from the top with jam. Wipe rims of jars clean and top with lids that have been boiled five minutes in a pan of water. Add screw-on band, and leave overnight to be sure they seal. Four quarts of chopped apricots make about 10 to 12 pints of jam.

ABOUT POTS AND LIDS

All the recipes for jam mention working with a nonreactive pot. Though I did not inherit a jam recipe from my mother, I did inherit her pot. It

is a dark blue-and-white enamel pan that is low and broad. The enamel is a good conductor of heat and seems to be ideal for cooking fruit and making jam.

Jam recipes often speak about lids and bands. The lid is essential to canning and cannot be reused. When you place a lid on the top of a jam jar, it is the device that will create your seal. It is held in place by what is called a band. A band screws on over the lid, and it—and the jar—can be reused.

SUN-KISSED APRICOT JAM

Margaret Hill Smith, the wife of Gilbert Smith, whose orchard surrounds city hall in Los Altos, liked to make her jam in the sun. After hunting around, I found the sun jam recipe below in an old scrapbook.

To make it work, you need a few hot days in a row, a good spot outdoors in direct sunlight and an old piece of glass about the size of a small window. We had a piece of glass lying around our house that used to cover the top of an end table, and it worked perfectly. I brought the jam in at night to avoid tempting the raccoons.

I left the jam in the sun for two nine-hour days. On the third day, it needed just three hours to finish cooking.

For sealing these jars, you will need to boil the lids, as jam made in the sun does not get as hot as jam made in a pot and might not get hot enough to create the heat differential that causes the seal. I find the idea of cooking with sunshine very appealing. Perhaps that is why it seemed to me the sun-kissed jam had the sweetest taste of all.

<div align="center">

INGREDIENTS

4 cups fresh diced apricots

4 cups granulated sugar

1/4 cup of lemon juice

</div>

Pour all ingredients into a shallow baking pan. Set in full sun and cover with glass (an old window will do). Place matchsticks between glass and pan to allow for air circulation. Stir occasionally. Leave until desired consistency, usually four days more or less, depending on the amount of sunshine.

Apricot jam, cooking in the sun. It doesn't heat up the kitchen or waste any expensive BTUs. *Photo by Robin Chapman.*

CLARA CALDWELL'S APRICOT LIQUEUR

The Colonel and Mrs. Caldwell lived up the street from us when my sister and I were children. This military couple had traveled the world between the two world wars, and I still remember their cool, dark living room with its exotic furnishings that included curio cabinets from China and the foot of an elephant that had been made into a wastebasket (a reminder of a much different time.) The couple entertained quite a bit, which may explain the origin of this recipe. It has been well tested in our family.

INGREDIENTS
1½ pounds dried apricots
1½ pounds rock sugar candy
½ gallon of vodka

Place the apricots and the rock sugar in a clean, wide-mouthed jar and pour the vodka over them. Put a lid on the jar and secure it tightly. Leave in a cool, dark place for 60 days. (You might want to put the date on the outside of the jar so you can keep track.) When the time is up, drain the liqueur off and place it in several small decanters. If the rock candy has strings, remove them now.

Some like to leave the mixture as it is, pouring it out from the original jar as needed, and returning the rest to the dark. The flavor gets stronger the longer you leave it to steep.

When you have consumed all the liquid (or transferred it to a decanter) you can use the infused dried apricots as a topping on ice cream, in a pudding or added to a fruitcake. Or, you can melt cooking chocolate in a saucepan and dip each apricot half into the chocolate and place the halves on to waxed paper to cool. Store in the refrigerator, and bring them out for special guests. Apricots and chocolate: it is hard to beat a confectionary combination like that.

APRICOT YUMMIES

This recipe comes from the Chapman family. I remember making it many times with my mother. You can use any kind of jam in the center. We used the jam we had on hand, which often happened to be apricot.

INGREDIENTS
¾ cup sugar
1 cup butter
1 egg
2 cups cake flour
¼ teaspoon almond extract
1 teaspoon vanilla extract

Beat the sugar, butter and egg together. Gradually sift the flour into the sugar, butter and egg mixture, stirring until thoroughly blended. When the batter is smooth, add the almond and vanilla extract. Drop the cookies onto a greased cookie sheet. Dip a spoon in water and make a center in each dropped portion of batter. Then place a teaspoon of apricot jam in the hole you've just made in each cookie.

Heat the oven to 325° F. Bake for about 10 minutes, until there is a hint of brown on each cookie.

APRICOT NUT BREAD

Our cousin Karen Wynbeek, who spent many years teaching in the Santa Clara Valley, contributed this recipe. Her home in Cupertino is on Steven's Creek, very near the place Anza and Father Pedro Font stopped with their party in the eighteenth century on their way to explore San Francisco Bay.

INGREDIENTS
1 cup of sugar
2 tablespoons margarine or butter
Cream these ingredients together, and add:
1 egg
¾ cup milk
¾ cup orange juice
4 teaspoons grated orange rind

Sift together:
3 cups of flour
3½ teaspoons of baking powder
1 teaspoon salt

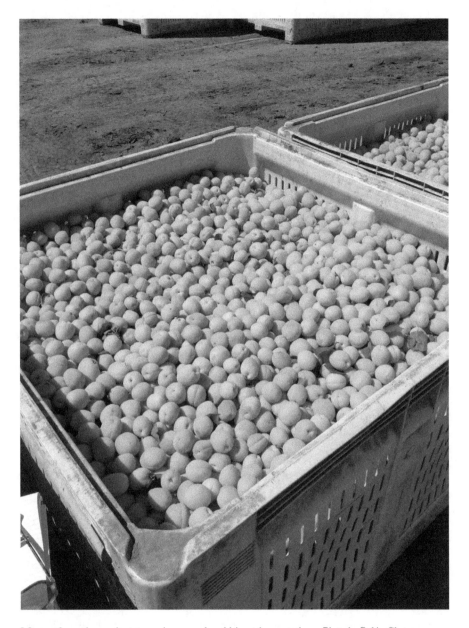

Manna from the apricot trees, in an orchard bin at harvest time. *Photo by Robin Chapman.*

After you have added the dry ingredients to the sugar and butter and milk mixture, add:

1 cup of finely chopped dried apricots
¾ cup of chopped nuts

Grease a loaf pan. Let mixture stand for 20 minutes. Bake at 350° F for about 70 minutes.

This apricot bread is not too sweet and makes great toast: just remember to cut up the dried 'cots into *very* small pieces. If you want to have it for dessert you can frost it with powdered sugar frosting. Or, you can drip melted butter on the top of the loaf and sprinkle it with cinnamon and sugar.

EASIEST APRICOT BREAD

Evelyn Mersman and her husband, Bill, lived across the street from us. When they moved to a larger house on Campbell Avenue, we often stopped by to see them on Christmas Eve as we drove home from church in Mountain View. Mrs. Mersman's apricot bread was among the deserts she would set out for her party.

INGREDIENTS
1 cup dried apricots, chopped
1 cup of sugar
2 tablespoons of butter
1 egg
¼ cup of water (saved from soaking the apricots)
½ cup of orange juice
2 cups of sifted flour
2 teaspoons baking powder
¼ teaspoon soda
¼ teaspoon salt

Cut up the apricots, cover with water and let stand for thirty minutes. Drain. Cream sugar and butter, add egg and beat. Stir in liquids. Stir in dry ingredients. Add ½ cup of chopped nuts and apricots. Let stand twenty minutes before baking. Place in greased loaf pans, lined with waxed paper. Bake at 350° F for one hour. Makes three small loaves.

APRICOT BARBECUE SAUCE

You may find it hard to sacrifice one of your precious jars of homemade apricot jam for barbecue sauce, but this curious combination has a great flavor. It is a sweet and sour mixture and is good on any kind of barbequed meat.

<div align="center">

INGREDIENTS

1 clove garlic, minced and mashed

1 teaspoon salt (optional)

1 cup chicken stock

1 cup apricot jam

¼ cup vinegar

¼ cup catsup

</div>

Place in saucepan and heat for a few minutes until all the ingredients are cooked together, but not long enough to scorch the jam. Pour over ribs or pork roast and marinate, then continue to brush on remainder of sauce as the meat cooks. (I found this recipe works best when you take out the lumpiest pieces in the apricot jam.)

APRICOT COBBLER

In 1988, the Los Altos History House (now the Los Altos History Museum) published a cookbook called *The Flavor of Los Altos.* The cookbook is now out of print, and the museum has graciously allowed me to use this recipe from the book. It comes from Joyce Buswell Frederick, whose family had a large apricot orchard off Los Altos Avenue, and whose father, Harry Buswell, came to the Santa Clara Valley in 1906.

The recipe is likely a mid-twentieth century one since a cake mix is used as one of its ingredients. Cake mixes were introduced into the United States in the 1920s but were not widely used until the 1940s, when women entered the work force in large numbers during World War II.

<div align="center">

INGREDIENTS

6 cups fresh apricots, halved and pitted

1 cup plus 2 tablespoons sugar

</div>

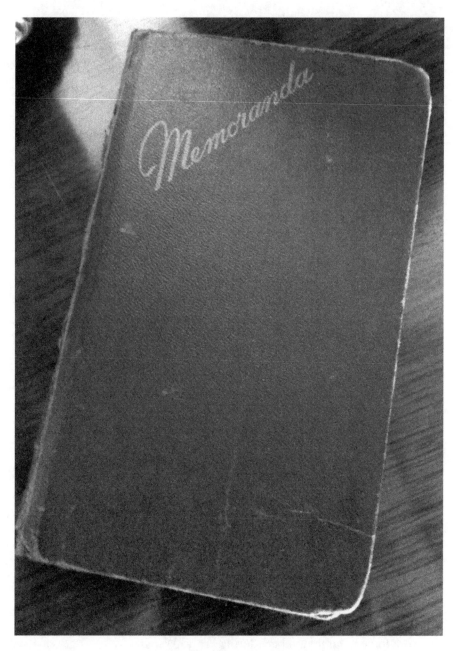

The memoranda book of the project that started it all. My father used this little book to keep track of the hours he worked on the house he built from 1947 to 1949. After he finished the house, he saved the notebook for the rest of his life. *Photo by Robin Chapman.*

10 teaspoons of flour
1 white cake mix

Cut off ends of apricots, then halve them removing the pits and cut into pieces. Mix together apricots, sugar and flour. Pour into a greased 9 x 12 pan. Make white cake mix according to directions on package. Pour cake mix on top of apricots. Bake at 350°F for 35-40 minutes or until cake is done. Cool. Top with vanilla ice cream.

CLARA VOJVODA'S APRICOT BARS

Clara Vojvoda (1900–1984) was the mother of Nick Vojvoda, who used to spray our apricot trees. Nick's daughter-in-law, Lee Ann McNeely Vojvoda, shared this much-loved recipe.

INGREDIENTS
1 cup dried apricots, cut into quarters
1 tablespoon butter
2 eggs, well beaten
1 cup granulated sugar
1 tablespoon lemon juice
1 cup sifted flour
1 teaspoon baking powder
½ cup raisins
½ cup canned pineapple, diced and well drained
confectioners' sugar, as needed

Put apricots in a pan, cover them with water and boil for ten minutes. Drain and set aside. Cream butter. Add eggs and sugar. Cream all together until light. Add lemon juice. Sift dry ingredients into mixture. Beat well. Add raisins, then pineapple and finally, add the apricots, mixing well after each addition.

Spread mixture evenly in greased and floured 8 x 8 x 2 pan. Bake 350° F for about 45 minutes or until brown. Remove from pan, cool and if desired dust with confectioners' sugar. Yield: Nine 2½-inch squares.

In our home, we never felt the need to be too imaginative in our use of apricots. We ate lots of fresh ones in the summer, and other than that, we

dried them, we canned them and we used them for jam. These recipes are a reminder that there are so many other things you can do with apricots. Just putting jam or the syrup from canned apricots on a scoop of ice cream produces a tasty dessert. Yogurt and apricot jam have been a popular combination in the Mediterranean for centuries.

Looking back, I remember, every now and then, my mother would make a fresh apricot pie. It isn't hard to do considering the spectacular result. You just make a pie crust, fill it with fresh apricot halves and cover the fruit with a homemade glaze. Put the rest of the crust on the top and bake it as you would a strawberry pie. We also, on occasion, made apricot nectar. Nectar is a thick juice made of cooked fruit that has been run through a strainer. You can use the pulp that is left over to add to your jam.

Once or twice, at the end of a warm summer day, we made apricot ice cream. Sitting in the backyard, we each took part in turning the hand crank of our old wooden ice cream maker. With the dappled sunlight filtering through the leaves of the trees and the scent of apricots all around us, it was a memorable time. "Those were Halcyon days," my father said in the last year of his life, and I had to agree. Like "an apricot in Damascus"—or better yet, like a Blenheim in the Santa Clara Valley—it just doesn't get any better than that.

AFTERWORD

The Second Orchard

When I tell people the story of the house my father built in the apricot orchard, it always makes them smile. When I further tell them that, upon the deaths of my parents, I moved into the family home, they often say how lucky I am to be living in the house my father built.

I am lucky. But I'm not living in the house my father built, and the story would not be complete without an explanation of how that came about.

My parents did live on the same street in Los Altos from the day they moved into their new home in 1949 until the day each of them died six decades later. But they did not live in the same *house* on that street for all those years.

In 1953, my parents watched as a new house rose in the apricot orchard across the street from their home. Though humble by valley standards today, it was larger than our house with several added features my mother liked. After we had lived in our first house for ten years, the house across the street came up for sale. My mother said it would be her dream to own a house like that, and my father bought it for her. Moving such a short distance, we only needed professional movers to carry grandmother's piano across the road and into our new living room.

As I got older, I often wondered how my father felt about this. Were his feelings hurt when, after he spent two years of weekends building a house for his family, my mother pointed to a house somebody else built and said she wanted that one instead? It took a long time for me to figure this out, but it was never like that for my father.

Robin Chapman during the Chapman family's move across the street, in Los Altos. *Chapman family collection.*

First of all, he was an engineer, and though you and I might look at a construction project and immediately jump to contemplating the end result (in this case, the house), to an engineer, it is the project that is interesting. Thus, my father enjoyed *building* the house and when that was over he turned the living-in-the-house business over to my mother. Meanwhile, he thought up new projects to work on, including setting up an apricot drying operation in our backyard. It explains why he kept the notebook all his life of the hours he spent building the house. He had absolutely loved *doing* it.

Secondly, and perhaps this should have been the first thing I mentioned, my father absolutely adored my mother. If he thought he could have made her happy by buying and moving into *all* of the houses on our street, one after another, he would have done exactly that to please her. She loved the new house. With his seemingly boundless energy, my father spent his spare time serving his country as an army reserve officer, winning trophies as a

sharpshooter, earning his masters degree, keeping his pilot's license up to date by flying in and out of Moffett Field, volunteering at his church and working in his garden. He was able to accomplish all this, content that he had pleased my mother so much with what, to him, had been a very simple gesture.

Over the years, the house we once lived in became an object of casual curiosity to us as it was owned by a succession of young couples who remodeled it, re-landscaped it, sold it and moved on. Gradually, the house became almost unrecognizable as the one we had once made our home.

At the beginning of the twenty-first century, after my sister and I had been long gone from the neighborhood, the house was torn down and a new house built in its place. My father, by now in his eighties, proved unsentimental about the whole thing. He posed, smiling, on the street in front of the house he had built with such care, a half-century before, just as the bulldozers had knocked it over.

I was living on the East Coast then and seeing that photo of my father in front of the house I had loved as a child, taught me so much. Bricks and mortar were just bricks and mortar to him. The house had been something to live in with his family until he moved to another one. It did turn out that building or buying any kind of a house in the valley was one of the best investments he ever made.

After my father died, my family and I inherited this second family home on the street where I was born and raised. I never thought I would move into it. But its value had increased so much over the years and there was so much family history stored within its walls, we thought twice about getting rid of it. So, I moved in, for the present.

Thanks to that happy circumstance, I was able to harvest the apricots from the Blenheim tree my parents planted out by the back gate, late in their lives. All the other, older apricot trees had died off by then. It was from the fruit of this new tree that I made my first jar of apricot jam. In my family home, it also came to me one day that I should learn more about the apricot business that so many of us remembered with such affection. And that led to this book.

It seems so curious to me now, having been raised by an engineer who stressed the importance of planning in our daily lives, that in the end, so many of the best things that happen to us are the things we never plan. Moving into my family's second house is just another example of this successful serendipity.

Acknowledgements

A rchivists toil in obscurity, but it is with them that the hard work of preserving our rich history rests. Without the help of so many of them in the Santa Clara Valley, I could not have written this book.

Jim Reed and his staff at History San Jose were gracious in helping me. Volunteer Nadine Nelson spent many hours with me sorting through historical photographs, and without her help, I would truly have been lost. I also want to mention the late orchard owner Burrell Leonard, who became a developer and philanthropist in the valley, but who took the time to leave many photographs and notes about the history of his apricot orchard business to History San Jose. It is clear how much he loved growing apricots. We are indebted to him for his thoughtful conservation. History San Jose, by the way, is located in the old Beechnut Cannery across from Kelley Park—an appropriate place to store the archives of this once-rich-in-orchards region.

Mary Hanel, the Library Program Coordinator for the Santa Clara City Library's Local History program, was like a well-informed guide: she pointed the way to many of the sources and resources that were invaluable in my research. At the Los Altos History Museum, Lisa Robinson and Stefanie Midlock helped me piece together the story of J. Gilbert Smith's life. It was Ms. Midlock who also turned up the wonderful treasure of Lyle Huestis's unpublished memoirs, *Apples of Gold in Settings of Silver,* about growing up in the Job apricot orchard on Grant Road. It was filled with wonderful details, which added greatly to my understanding of life in the valley seventy-five years ago. Laura Bajuk, executive director of the Los Altos History Museum,

is a historian with long experience in research. One day, when I stopped by the museum feeling a little stuck, she talked with me about the book, and her enthusiasm got me back on track. "All research work takes us on a journey," she told me. "Focus on where this is taking you."

Bill Ferriera, president of the Apricot Producers of California, spent most of one warm summer day with me, giving me a tour of the modern apricot harvest near Patterson, California, and filling me with apricot factoids. Over the months, he also answered question after question from me about the apricot business. He introduced me to apricot grower Gene Bays, who, even though he was in the middle of the busiest season of his year, took the time to talk with me. Mr. Bays gave me a box of fresh apricots, and they filled my car with their lovely perfume as I headed back over Pacheco Pass. (They also made good eating when I got home.)

My thanks also to Mr. and Mrs. Peter Pavlina, Andy Mariani, Charles Olson, Mike McKinney, Yvonne Jacobson and John Vojovda and his wife, Lee Ann—among many others—for taking the time to reminisce with me about their family histories and for sharing with me the things they recall about the apricot business in the Santa Clara Valley.

For details about the origin of the apricot, I relied on a fascinating book, *The Origin and Dissemination of Prunus Crops: Peach, Cherry, Apricot, Plum and Almond*, edited by Jules Janick of Purdue University. Most of the contributors to his work were or are from Hungary, attesting to the continued importance of these stone fruits in Eastern Europe.

For those who want to read more about the orchard business in the Santa Clara Valley, Yvonne Jacobson's wonderful book—*Passing Farms, Enduring Values: California's Santa Clara Valley*—is the definitive resource. Mrs. Jacobson is a daughter of the orchards, which informs every page of her work. Written with a grant from the National Endowment for the Arts, Stanford professor and novelist Wallace Stegner was one of the work's "readers." Mrs. Jacobson told me how Mr. Stegner would say to her, "Just run it through the typewriter one more time!" Then, one day he said, "This baby is ready to roll." He could not have been more right in that. I can't recommend this book highly enough.

Finally, a special note of thanks to all my classmates from Loyola Elementary School, Covington Junior High and Los Altos High School who cheered me on—whether in person or with electronic messages. Many shared their memories with me of growing up amidst the apricot trees, and I am indebted to these old friends. We shared everything from kickball games to apricot summers. Now, we also share the joy of having lived in an era of so much beauty and bounty in the Golden State.

Bibliography

Arbuckle, Clyde, and Ralph Rambo. *Santa Clara County Ranchos.* San Jose, CA: Rosicrucian Press, Ltd., 1968.

Arnold, Lisa Gutt. "Cutting 'Cots in the Santa Clara Valley." *Robin Chapman News,* June 16, 2009. robinchapmannews.blogspot.com.

Bancroft, Hubert Howe. *History of California.* San Francisco: The History Company, 1890.

Beebe, Rose Marie, and Robert M. Senkewicz. *Lands of Promise and Despair: Chronicles of Early California, 1535–1846.* Berkeley, CA: Heyday Books, 2001.

Boriss, Hayley, Henrich Brunke, and Marcia Kreith. "Commodity Profile: Apricots." Davis: University of California Agricultural Issues Center, February 2006.

Callison, Barbara Collins. *Growing Up in Los Altos.* Los Altos: self-published, 1992.

Chapman, William Ashley. Letters to Faye E. Chapman. January 1945 to November 1945. Chapman family collection, unpublished.

Consigny, Jean Marie. "Four California Gardens." *California History Nugget* 5, no. 3 (December 1937): 67–70.

Couchman, Robert. *The Sunsweet Story.* San Jose, CA: Sunsweet Growers, Inc., 1967.

De Murville, Couve M.N.L. *The Man Who Founded California.* San Francisco: Ignatius Press, 2000.

Ferriera, William C. Interview with the author, June 21, 2012. Patterson, California.

Flavor of Los Altos. Los Altos: History House Books, Los Altos History House Museum Publication, 1988.

Garcia, Lorie, George Giacomini, and Geoffrey Goodfellow. *A Place of Promise: The City of Santa Clara, 1852–2002.* Santa Clara, CA: City of Santa Clara, 2002.

Gollner, Adam Leith. "The Glabrous Fruit of Samarkand." *Lucky Peach,* December 2011, 30–40.

Gomez-Redondo, Rosa, and Carl Boe. "Decomposition Analysis of Spanish Life Expectancy at Birth." Rostock, Germany: Max Planck Institute for Demographic Research, November 2005.

Goodwin, Doris Kearns. *Team of Rivals: The Political Genius of Abraham Lincoln.* New York: Simon and Schuster, 2005.

Guerrero, Vladimir. *The Anza Trail and the Settling of California.* Berkeley, CA: Heyday Books, 2006.

Hendrickson, Arthur Howard. "Apricot Growing in California." *California Agricultural Extension Division, Circular 51* (December 1930). College of Agriculture, University of California–Berkeley.

Huestis, Lyle W. *Apples of Gold in Settings of Silver.* Los Altos History Museum archives, unpublished memoir, 1977.

Hutchings, Robin. "Pioneer Home Which Will House Los Altos History Will Be Dedicated on City Birthday." *Los Altos Town Crier,* November 30, 1977.

Jackson, Helen Hunt. *Ramona.* New York: Penguin Group, Inc., 2002. First published in 1884.

Jacobson, Yvonne. *Passing Farms, Enduring Values: California's Santa Clara Valley.* Cupertino: California History Center Foundation, 2001.

———. Telephone interview with the author, December 10, 2012.

Janick, Jules. "The Origins of Fruits, Fruit Growing, and Fruit Breeding." West Lafayette, IN: Department of Horticulture and Landscape Architecture, Purdue University, 2005.

Janick, Jules, Miklos Faust, Dezsö Surányi, and Ferenc Nyujtó. *Origin and Dissemination of Prunus Crops: Peach, Cherry, Apricot, Plum and Almond.* Gent-Oostakker, Belgium: International Society for Horticultural Science, 2011.

Kerschner, Art, et al. *Report on the Youth Labor Force: Child Labor Laws and Enforcement,* Bureau of Labor Statistics, U.S. Department of Labor, November 2000.

Kimbro, Edna E., and Julia G. Costello. *The California Missions: History, Art and Preservation.* Los Angeles: Getty Conservation Institute, 2009.

Lake, Alison. *Colonial Rosary: The Spanish and Indian Missions of California.* Athens: Ohio University Press, 2006.

Los Altos Historical Museum. "History of History House." Scrapbook collected June 14, 1987. Los Altos History Museum.

Los Altos News. "City Council Lauds Smiths: Center Site Accord Reached." December 10, 1954.

Los Altos Quota Club. *A Harvest of Apricot Recipes.* Los Altos: Los Altos Quota Club, 1970.

Los Altos Town Crier. "Charles Michael Viscovich: From the Orchard to the Sea," November 28, 2012.

———. "City Orchard Wins Historical Status," May 20, 1981.

———. "Landscaping Proposal for History House Draws Rave Reviews from City Council," September 21, 1977.

———. "Pioneer Home Which Will House Los Altos History Will Be Dedicated on City Birthday," November 30, 1977.

Mariani, Andrew. Telephone interview with the author, January 15, 2013.

Marinacci, Barbara and Rudy. *California's Spanish Place Names: What They Mean and the History They Reveal.* Santa Monica, CA: Angel City Press, 2005.

"Market Conditions & Quotations: Dried Fruits." *California Fruit News* 58, no. 1570 (August 10, 1918): 8–10.

McDonald, Don. *Early Los Altos and Los Altos Hills.* Charleston: Arcadia Publishing, 2010.

McKnight, Dana Moore. Written electronic correspondence with the author regarding apricots in Uzbekistan. August 2012.

Munro-Fraser, J.P. *History of Santa Clara County, California.* San Francisco: Alley, Bowen, & Co., 1881.

Olson, Charles. Telephone interview with the author, January 28, 2013.

Palo Alto Times. "Los Altans to Celebrate Silver Anniversary: New Historical Museum to Open," November 29, 1977.

Parsons, Mary Elizabeth. *The Wild Flowers of California.* Berkeley, CA: James J. Gillick & Co., 1955. First published in 1887.

Pavlina, Peter and Carole. Interview with the author, June 26, 2012.

Payne, Stephen M. *Santa Clara County: Harvest of Change.* Northridge, CA: County of Santa Clara Historical Heritage Commission, 1987.

Rambo, Ralph. *Adventure Valley: Stories of Santa Clara Valley Pioneers.* San Jose, CA: Rosicrucian Press, Ltd., 1970.

"Reminiscences of J. Gilbert Smith." In *Memories of Los Altos.* Los Altos: Los Altos Historical Association, 1982.

Richards, Sally. *Silicon Valley: Sand Dreams & Silicon Orchards.* Carlsbad, CA: Heritage Media Corp, 2000.

Richter, Ruthann. "Memories of an Early Los Altos." *Peninsula Times-Tribune,* April 21, 1983.

Salameda, Joseph. *Memories of Los Altos.* Los Altos: Los Altos Historical Association, 1982.

San Jose Business Journal. "From Farms to Fabs: 100 Years of Business in the Valley." December 24, 1999.

San Jose Historical Museum Association. *Sunshine, Fruit and Flowers: Santa Clara County, California.* San Jose, CA: Alfred C. Eaton, 1986. First published in 1886.

San Jose Mercury News. "Home and Garden to Become Museum," July 1, 1981.

Saratoga Heritage Resources Inventory. Saratoga, CA: City of Saratoga Planning Department, December 2009.

Sawyer, Eugene T. *History of Santa Clara County, California.* Los Angeles: Historic Record Company, 1922.

Shepherd, Tuck. "History House Garden Evidences Results of Helping Hands and TLC." *Los Altos Town Crier,* May 13, 1981.

———. "Oldtimers Recall Los Altos' Past." *Los Altos Town Crier,* August 8, 1981.

Smith, Daphne, and Norene Rickson. Oral history interview by Marion Grimm, August 7, 1994. Transcript in the Los Altos History Museum archives.

State of California. *California Statistical Abstract, 1970.* State of California Research Unit, State Department of Finance: 11th Edition, 1970.

Toomey, Donald Francis. *The Spell of California's Spanish Colonial Missions.* Santa Fe: Sunstone Press, 2001.

Traugott, Elisabeth. "Historic Preservation: Apple's Jobs Can Pursue Apricot Dream." *Palo Alto Weekly,* August 22, 1997.

Vojvoda, John. Interview with the author, November 14, 2012, Los Altos.

Walker, Dale L. *Bear Flag Rising: The Conquest of California, 1846.* New York: Forge Books, 1999.

Warburton, Austen D. *Santa Clara Sagas.* Cupertino: California History Center and Foundation, 1996.

Wickson, Edward J. *The California Fruits and How to Grow Them.* San Francisco: Pacific Rural Press, 1914 and 1926.

Wills, Mary H. *A Winter in California.* Norristown, PA: M.R. Willis, 1889.

Index

About the Author

R obin Chapman is a native of the Santa Clara Valley who earned a masters degree at University of California–Los Angeles before setting out on a career in television news. During her years as a journalist, she worked as a reporter and anchor at KVOA-TV in Tucson, Arizona; KGW-TV in Portland, Oregon; KRON-TV in San Francisco; WJLA-TV in Washington, D.C.; WESH-TV in Orlando, Florida; and as a national correspondent in Washington D.C. for Group W-TV. During her years in news, as she covered stories from the White House to Operation Desert Storm, she also developed an interest in regional history, publishing articles in newspapers and journals throughout the country. In 2009, she returned to California to be closer to her elderly parents and, following their deaths, decided to resettle in her home state. This is her fourth book of regional history and her first about California.

The author with her father, Colonel William Ashley Chapman, in Shoup Park. He passed away just a few years later, in March 2010, at the age of ninety. *Chapman family collection.*